LIVING LANDSCAPES OF Kansas

Text by O. J. Reichman *Photographs by* Steve Mulligan

LIVING LANDSCAPES OF
Kansas

UNIVERSITY PRESS OF KANSAS

This book was photographed with
a 4x5 Toyo field camera. The color was
shot on Kodak Ektachrome and Fuji
Velvia transparency film, and the black
and white film was Ilford FP-4, printed
on Oriental Seagull paper. Exposures
ranged from 1/4 second to 5 minutes
and mild filtration was occasionally
employed.

Published by the University Press of Kansas (Lawrence, Kansas 66049), which
was organized by the Kansas Board of Regents and is operated and funded by
Emporia State University, Fort Hays State University, Kansas State University,
Pittsburg State University, the University of Kansas, and Wichita State University

Library of Congress Cataloguing-in-Publication Data

Reichman, O. J., 1947–

Living landscapes of Kansas / text by O. J. Reichman :

photographs by Steve Mulligan.

p. cm.

ISBN 0-7006-0727-7 (cloth : alk paper)

1. Kansas—Pictorial works. 2. Kansas—Description and travel.

3. Landforms—Kansas—Pictorial works. 4. Landforms—Kansas.

I. Mulligan, Steve. II. Title

F682.R44 1995

917.81—dc20 95-4636

British Library Cataloguing in Publication Data is available

Printed in Hong Kong

10 9 8 7 6 5 4 3 2 1

This is for Vic and Alyssa,

the two loves of my life

S.M.

To my mother, who read to me

and taught me to read, and to

Jessica, who as editor of first

resort helps me to write.

J.R.

CONTENTS

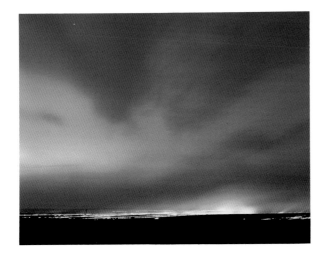

ACKNOWLEDGMENTS

The inspiration for this book came from two sources. The first was a lure cast out by Fred Woodward of the University Press of Kansas, who urged me to consider writing the text for the book (with encouragement from Susan Schott). The hook was set when it became clear that Steve Mulligan would do the photographs to accompany the text (although I view the text as accompanying the photographs). The intensity of Steve's photographs reveals his patience and good eye that have imbued this book with a sense of the natural landscapes of Kansas.

Alan Pollom of the Kansas Office of the Nature Conservancy was particularly helpful in the early development of the book (he also pointed out Steve Mulligan's work), and Rex Buchanan of the Kansas Geological Survey provided an excellent critical review of a draft of the text. Dr. Craig Freeman provided guidance throughout the preparation of the book, for he is someone who both knows and understands Kansas. His efforts are characterized by dedication and professionalism that are enviable.

Finally, I thank my wife Jessica, whose enthusiasm, encouragement, and assistance made it all possible and enjoyable.

— J. R.

I began photographing in Kansas on a whim, never expecting to find the wonderful landscape diversity that exists here. During the four years I have worked on this project, I have fallen in love with Kansas, both the land and its people. I certainly owe a debt of gratitude to the people of Kansas; they are, without a doubt, the most generous and friendly population in the entire United States. Without their kindness, this book would never have happened.

It is impossible to thank all of the people who assisted me in the making of this book, but there are several who must be mentioned. My parents, Don and Diane Mulligan, have always supported and encouraged me and deserve a never-ending thank-you. My sister Julie has also been extremely supportive and gets a big thanks. My mother- and father-in-law, Judy and Larry Gigliotti, are the two most selfless people I have ever known, and the ease with which I entered their family still amazes me. My three brothers-in-law, Steve,

Andrew, and Matt Gigliotti, have all, at one point or another, helped me on photo trips, and the trio deserves many kudos.

The directors of the Kansas Office of the Nature Conservancy and Alan Pollom (as well as his office staff) have been of incalculable help in the preparation of this book. For opening all of their beautiful preserves to me, and for offering a constant list of potential photographic subjects, I offer them my thanks.

Multiple thank-yous to John Botkin and the staff at the Photocraft Lab, who make everything so much easier with personal attention and prompt service.

For Tom Till, who has been a generous friend and selfless mentor to me for many years, mahalo.

The staff at the University Press of Kansas also deserves mention, as they have been extremely easy to work with from the get-go. Fred and Susan, in particular, have helped and never hindered.

— S. M.

Generalized Physiographic Map of Kansas

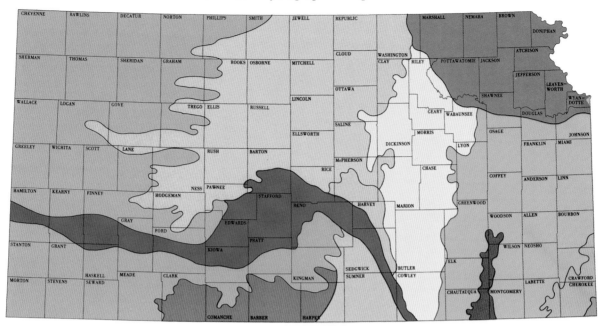

EXPLANATION

HIGH PLAINS

SMOKY HILLS

ARKANSAS RIVER LOWLANDS

WELLINGTON-MCPHERSON LOWLANDS

GLACIATED REGION

OSAGE CUESTAS

FLINT HILLS UPLANDS

RED HILLS

OZARK PLATEAU

CHEROKEE LOWLANDS

CHAUTAUQUA HILLS

0 100 mi

Kansas Geological Survey

INTRODUCTION

Having spent most of my adult life in the West, I arrived in Kansas possessing all of the stereotypical visions of the Midwest, and this state in particular. I had hiked, skied, and rafted the natural habitats of the West and appreciated their profound beauty. But as I flew into Manhattan on a sunny afternoon, I was struck by the ripples on the surface of the Flint Hills. This wasn't at all what I had expected. On the ground, it became clear that the landscape was covered in a fine wrapping of magnificent grass, bound neatly by ribbons of streams and their accompanying forests.

Now, after years of living in Kansas and working on the Konza Prairie, it is clear to me that this is a place that seems to have no intermediate view – it must either be peered into, within a radius of 10 to 15 feet, or scanned along the horizon. Kansas was not formed by dramatic geological processes such as the upwelling of the Rockies or the pounding surf of the coasts. Rather the landscape has been finessed, producing something subtle and fetching. This knowledge yields, for me, a feeling that the prairies are not something awesome that must be feared or overcome, but more a part of me.

From the human perspective, Kansas is a bountiful land. Its rich pastures once supported a herd of 4 million bison and still support much of the nation's livestock industry. Its deep prairie soils now feed much of North America and other parts of the world. But this book is not about the domesticated portions of Kansas. It is about what remains of its wild landscape, the subtle beauty of its prairies, forests, streams, and rivers. It is about learning to look deeply into these wild places and to understand their importance in the region and in the world.

Our view of Kansas changes with the scale of observation. If we look at Kansas from space, it appears relatively flat and uniform in color. In the summer, the eastern third would look green, and the area from the hundredth meridian west of Hays would be shaded beige. In the winter it would appear brown, except where recent storms had laid down swaths of snow.

Lower down, near the edge of the stratosphere, both natural features and those generated by human activity begin to emerge. Streams and rivers become barely visible and the splotches produced by center-pivot irrigation become identifiable as manmade.

From the altitude of commercial aviation – 28 to 39 thousand feet – our view encompasses hundreds of square miles, and recognizable topographic features such as hills and

valleys emerge. With a closer look, perhaps from the height of a few hundred to a few thousand feet, we clearly see many familiar features. Streams, including their channels, banks, and riparian vegetation, are traceable. Large trees can be individually distinguished from this height, though the canopy of the tallgrass prairie still appears continuous.

Only when we reach ground level do we experience Kansas at a familiar scale. From here we can see over the grasses and lean against individual trees. We step into streams and actually feel their coolness. We smell the fragrant air on a humid morning or taste the bitter juice of a grass stem pulled from its protective sheath.

Once we move beyond this familiar scale of perception into the subterranean or microscopic world, the views again become unfamiliar. Although we cannot peer into this world without special assistance, we can detect hints of its importance through the effects of the minute grinding of silt-laden streams or through the pungent smell of microbes decomposing vegetation or dead animals.

Our sense of time is also keyed to our own field of perception. We cannot comprehend the earth's age – 4.6 billion years – or imagine that life has existed on the planet for over three-quarters of that time. Even the recession of the glaciers only a hundred thousand years ago tests the limits of our imagination. Though we may accept the idea that much of what is Kansas was determined long before that, we cannot conceive of time periods many thousand times the length of our own life spans.

Perhaps we can picture the arrival of humans around 10 thousand years ago, as they traversed the Bering Land Bridge from Asia to North America and journeyed south. We can also imagine the arrival of Europeans on this continent in the fifteenth century and the colonization of what was to become the United States almost 400 years ago. Our country is over 200 years old, but only when we get to the age of Kansas (134 years) do we begin to feel time through our connection with ancestors we know by name. Even so, we have difficulty thinking much further back than our grandparents' generation, which, for some of us, includes the founders of Kansas.

Once we enter the realm of our own lifetimes we can detect events that are directly meaningful to us. Severe droughts or floods might occur several times during this span, and we might have a close encounter with a tornado once or twice. Every 10 years or so the summer is especially hot or winter generates a dangerous ice storm. But even though we know these events will happen a number of times during our lifetimes, we cannot sense a rhythm that suits our nature.

Rather, it is the seasonal cycle, green to brown and back again to green, that is tangible to us. Even before the leaves blow off the trees in the fall we intuitively know that the sun is lower in the southern sky. The first cool, dry morning breeze yields a subliminal clue that fall is arriving, much as a particular scent may remind us of someone we love. The singing of birds early in the year signals that spring is on the way, and in much of Kansas we have learned that the smell of prairie burning means April has arrived.

As humans we are situated in a midrange of scales of space and time. Without optical aids we cannot see the minute or the distant. Neither can we appreciate even the millennium-to-millennium events of the past or predict the future on any scale. But Kansas, the middle ground, is perfectly suited for human beings to appreciate. It is a subtle landscape where we can part the grass of the prairie and see the soil, amble under the forest canopy, or wade in the streams. Rather than dramatic landscapes like the Rocky Mountains or the coasts, we are surrounded by broad vistas of prairie landscape, where the horizon seems within reach – perhaps only a long day's hike away.

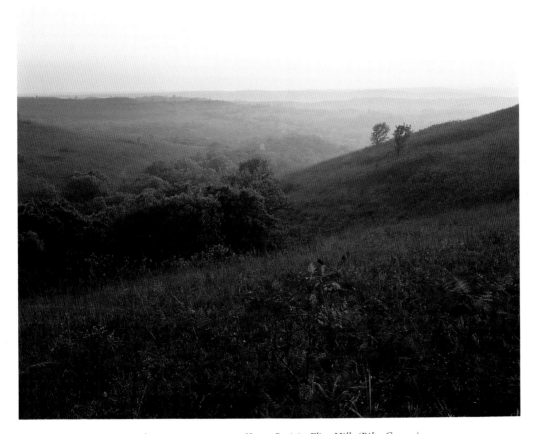

Early autumn morning on Konza Prairie, Flint Hills (Riley County)

EARTH, FIRE, WIND, AND WATER

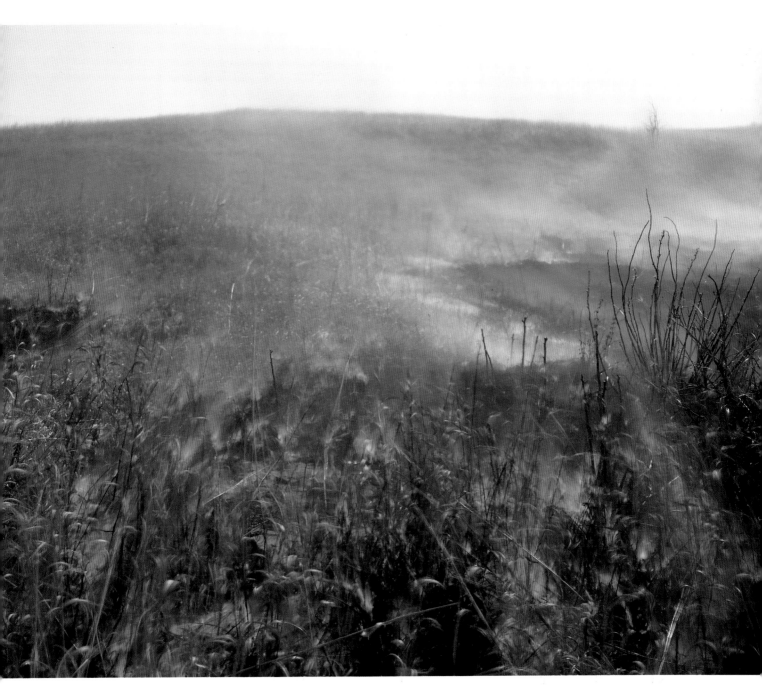

Spring fire on Konza Prairie, a common and natural process that is responsible for maintaining native prairie vegetation. (Riley County)

Most people would describe Kansas as flat or gently rolling. This perception is due, in part, to the mantle of vegetation that covers the ground and softens its contours. Even denuded, though, Kansas would appear smooth, with broad, relatively flat expanses and rounded edges at several scales. Roundness, in geological terms, implies time – time for the land to be worn by the forces of erosion, time for low areas to fill with eroded material pulled down by gravity, and 25 million years of time for enormous amounts of wind- and water-borne debris to spread from Colorado over western Kansas.

Compared to the continent's edges, the geologic history of Kansas has been more placid than wrenching. Kansas has few seismic scars or volcanic apertures, only a deeply buried fault here, some exposed igneous intrusions there. Traces of the state's benign geologic past can be read by the practiced eye, but the process is inexact, since the most obvious features of the landscape – those exposed on the surface – are also among the most altered by the atmosphere, climate, and current inhabitants. For a true sense of the past, one must read between the lines.

Though we are often instructed not to judge a book by its cover, that principle doesn't hold true for the land. In fact, the quickest way to determine the structure and history of the land is to examine its cover. To understand the structure of the land and imagine its past, investigators must probe the depths for evidence. They've developed ingenious tools and techniques for this purpose. Some are simple, such as observing natural cuts in the land or those made along major highways that allow geologists to peek below the surface. Others involve core samples extracted from far below the surface. From data provided by these samples, geologists can begin to sketch three-dimensional maps of subterranean features. Recently developed instruments, such as seismic thumpers and ground-penetrating radar, help them fill in the details of their portrait. But even with today's most sophisticated instruments, we can only glimpse what lies below ground. From bits and pieces of information we must imagine the links and interactions that produced the present lay of the land.

The foundation of Kansas, like the rest of the planet, was created when the newly formed earth, which was in a liquid state, began to cool below the boiling point of the lighter elements, including those that are silicon-based. These lighter elements then rose to the surface and solidified. They, along with many other constituents, formed the crust of the land. None of this primeval crust lies on the earth's surface today, though remnants of it exist thousands of feet below.

Once the basic mantle of the earth congealed, regional events began to shape what was destined to become Kansas. Igneous rock (formed from molten material) and meta-

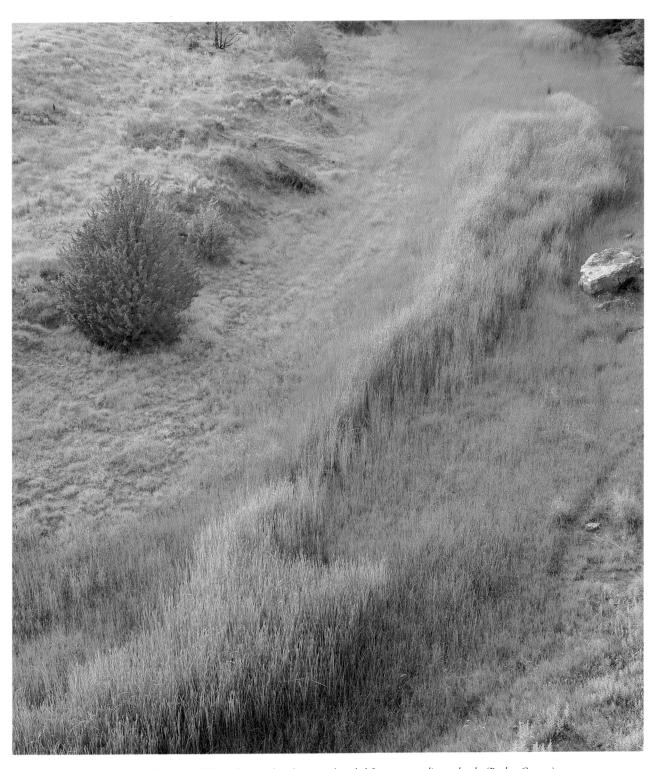

Grasses and even trees fill in a low pond with material eroded from surrounding uplands. (Barber County)

morphic rock (material buried and structurally altered by the overlying pressure and surrounding heat) became the new skin of Kansas. This skin was rough from the beginning, but it became truly contoured only when the forces of erosion – wind and water – carved patterns in its surface.

Between 350 and 550 million years ago Kansas was repeatedly flooded by seawater. About a hundred times the sea advanced and retreated, and with each advance, it laid down new layers of sediment. With each retreat, the new layers were exposed to erosion and either modified or abraded away before the next invasion.

It may be easier to imagine this process if we observe it on the small scale of a farm pond. Seasonally, waters fill the manmade depression and produce a shallow, murky soup. During rainstorms, mud washes into the ponds and adds to the turbidity, eventually filling the pond with silt. When the dry season comes and the water level declines, rills form in the exposed, barren edges of the pond and widen to small canyons in the runoff from rainstorms.

The alternating marine and terrestrial environments continued until about 60 million years ago. During the periods when Kansas was above the surface of the sea, the local environment was warm, moist, and bountiful, producing the enormous biomass that would become the coal beds of eastern Kansas.

Since the last withdrawal of the sea about 60 million years ago, the surface of Kansas has undergone perpetual erosion. In eastern Kansas, where erosion has been especially pronounced, layers of deposition from entire geologic periods are missing, scoured away cleanly. The Triassic period is unrepresented in Kansas for that reason – an unfortunate loss, since dinosaurs were at their peak during this epoch.

Though we often think of erosion as a series of large-scale events – chunks of earth falling into a flooding river or massive mud slides in torrential rains – that image probably reflects, again, our tendency to imagine events detectable in our own frames of reference. But erosion on a broad scale is a process almost imperceptible to us. It is the gradual but incessant sandpapering of silt on rocks driven by the force of wind or water over periods of time beyond our conception. Major storms occur infrequently, but the wind blows every day in Kansas, and every exposed surface is abraded constantly, in direct proportion to the force of the wind and volume of its load.

Erosion in Kansas over the last 60 million years has been counterbalanced by the large quantities of rock and soil abraded from the Rocky Mountains and either blown or washed eastward into the western two-thirds of the state. These gravel, sand, and silt deposits give this portion of the state its current plains character. More recently, in the last

Facing page: Limestone strata deposited by scores of intrusions and recessions of shallow seas over the landscape of Kansas. These bluffs exhibit one of the initial steps in erosion: the ablation of large pieces of rock, which are subsequently broken into smaller and smaller pieces until they become dust. (Cedar Bluffs, Trego County)

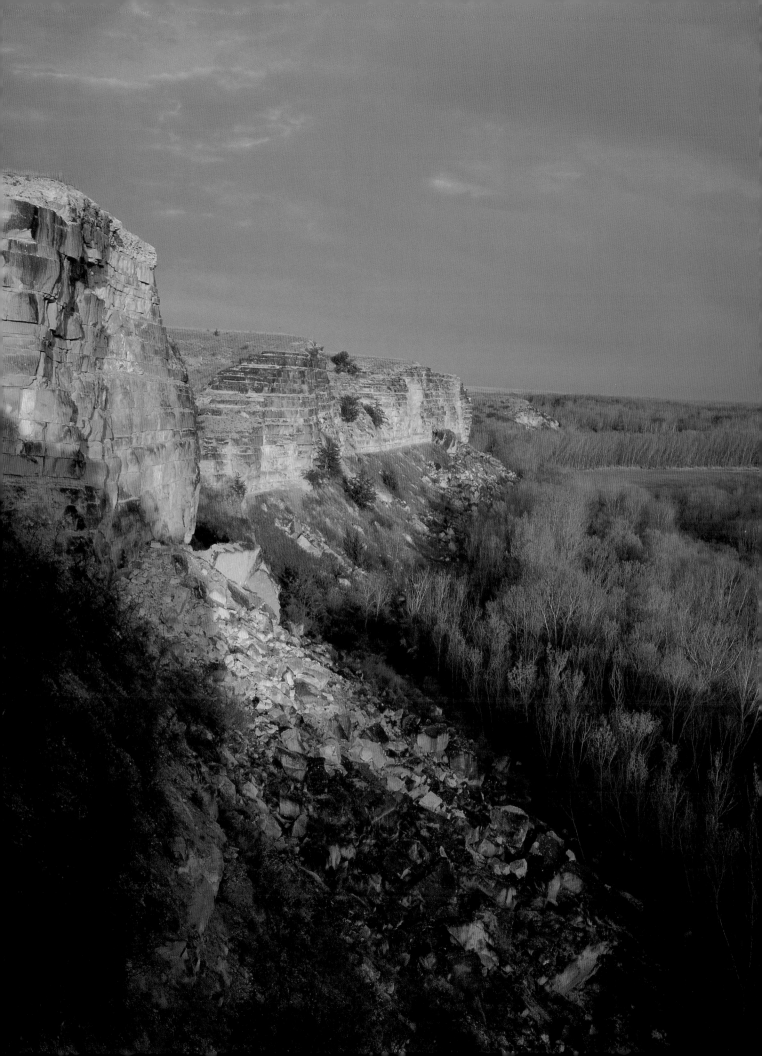

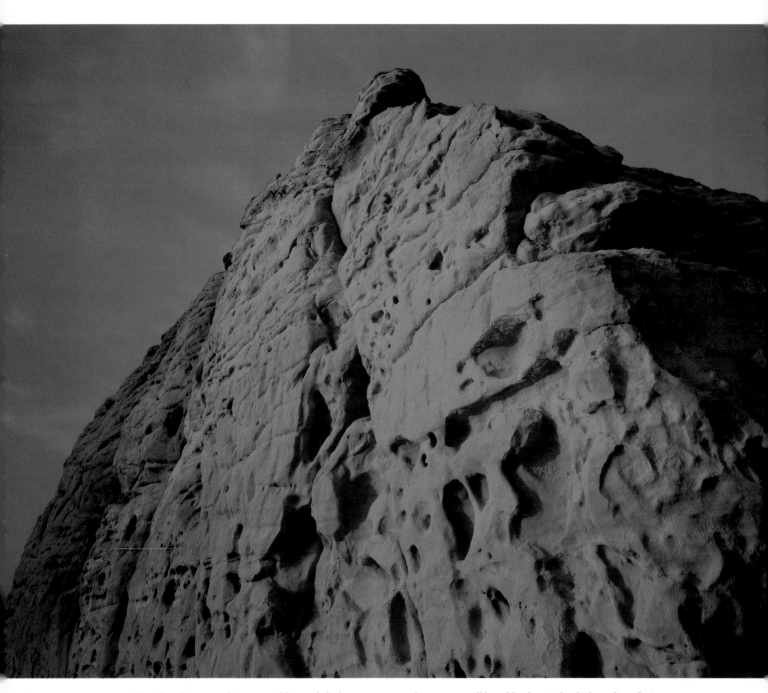

Now that the surrounding material has eroded, these emergent sandstones are sandblasted by the wind, which produces fluting on the surfaces of the rock. (Rocktown Natural Area, Russell County)

Facing page: Ireland Sandstone, deposited millions of years ago in layers of varying thickness. Erosion by the adjacent stream has revealed the strata. (Douglas County)

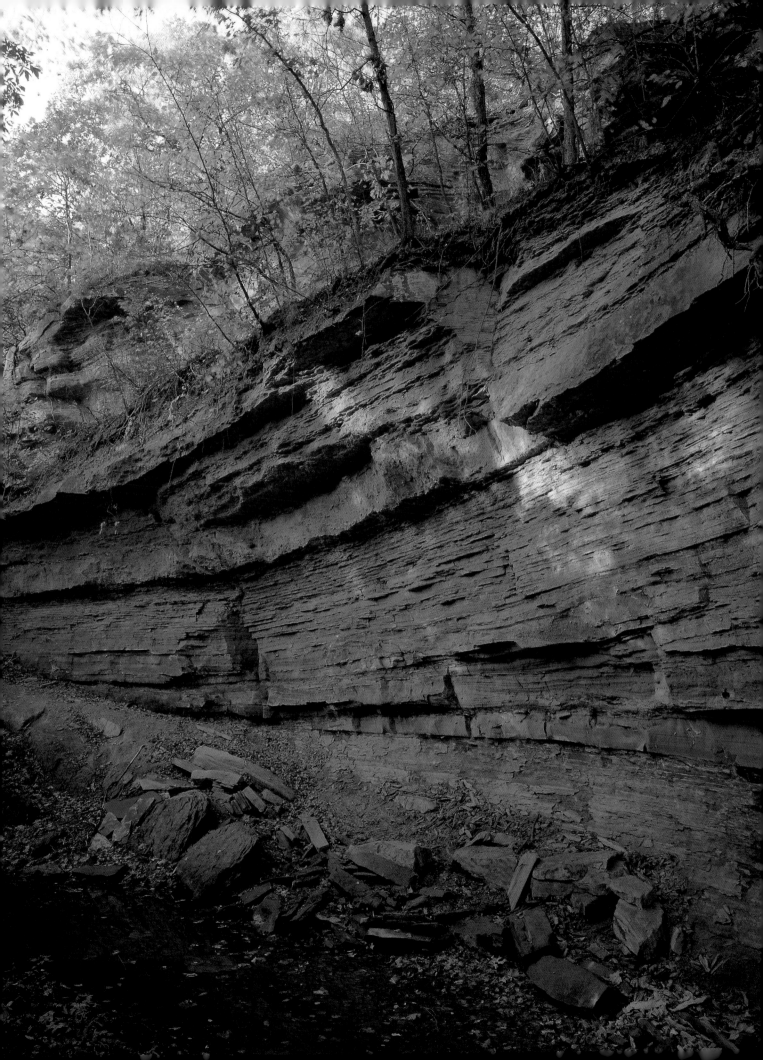

several hundred thousand years, ash has been deposited from distant volcanic activity, and airborne soil as fine as flour has blown in as glaciers ground the earth to dust.

This particular geologic history means that the surface of Kansas is almost completely covered by two different types of sedimentary rocks. The first is made of material eroded away elsewhere and transported to Kansas (as with sandstone or shale); the second is formed from the accumulation of the carcasses of ancient shelled animals (limestone). In waters made turbid by suspended silt or the skeletons of tiny creatures, a perpetual settling of particles produced thick layers of sediment. Over time, pressure from the overlying layers eventually presses the material into rock. The resulting pattern is a layer cake of shale, sandstone, and limestone, with the order of the layers revealing the story of their deposition. In Kansas the initial succession of deposits generally has not been jumbled by massive movements of the earth's crust. Here layers remain in the order they were deposited, with the youngest on top, leaving a fairly clear picture of past events. The primary confusion arises from the missing layers – those completely eroded away before the next layer was deposited.

Wind, water, and gravity are always shaving away any protuberance, planing off the surface to produce grist for the depositional mill. The eroded material is pulled downhill by gravity, so that even sand and dust blown through the air eventually work their way downward toward the lowest level. Water, too, carries its load of debris downhill and fills low-lying areas. The same forces work on the calcareous skeletons of shelled animals, yielding uniform layers of their remains.

The net effect of the sedimentary and erosional processes is a leveling of the landscape. Local isolated events, such as blowouts (deep depressions in sandy soil caused by air currents) or swiftly flowing water channels, disrupt the regional pattern, but these discontinuities are minor disturbances in a perpetual process. If the crushing forces of major land movements that can deflect and contort these layers are absent, as is the case in Kansas, the result is relatively horizontal layers.

Years ago, as a graduate student, I laughed at a professor's claim that Kansas was an excellent place to study stratigraphy (the relationship of the earth's layers to each other). Relying on a naive impression that all important geology was related to dramatic events, I thought the regions of major mountain building would be much more revealing than the layers of rock deposited under calmer circumstances. However, a drive west on I-70 provided me with a dramatic trip through geologic history. There the road cuts pass through epoch after epoch of sedimentary events that trapped for posterity the climates and creatures of their time.

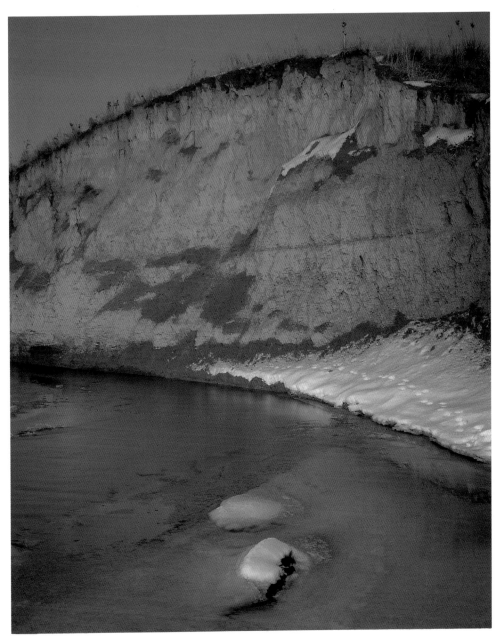

Material eroded from the Rocky Mountains over millions of years and deposited over the western third of Kansas. These fine sand and silt deposits will soon crumble back into the water and be transported downstream. (Arikaree River, Cheyenne County)

Kansas is not, however, composed of perfectly flat layers. The older layers – those up to about 60 million years old – form a gentle basin with the lowest point almost centered in the state. The edges of the basin rise gently in all directions, displaying tilted beds of this age in both the east and west, and extend well beyond the current state boundaries.

In the eastern third of Kansas the tilted layers are the dominant landform. When the beds tilted up, layers that differed in their susceptibility to erosion were revealed. To vi-

sualize this process and its result, imagine a stack of books; their hard covers are resistant limestone and the pages are softer shale. If you were to push over the stack so that it tilts to the left (or west in Kansas), the edges of the alternating layers would form a series of ripples on the surface with the hard covers emerging slightly above the softer pages. This pattern persists today over much of eastern Kansas, from just east of Salina to the Missouri border, in the form of wave-like cuestas and, to a lesser extent, in the Flint Hills.

Were it not for the Colorado Rockies, western Kansas would be a mirror image of the eastern third of the state, with strata tilted up to the west from the central basin. However, over the last 60 million years two processes changed the western half of the state; it was gradually uplifted as the mountains were formed, and it was covered with material eroded from the Rockies. The resulting long, gently sloping mantle of debris buried and obscured the underlying tilted beds. Rivers and streams originating within Kansas or in adjacent states gradually carved long east-west valleys in this depositional delta and produced a rugged topography that belies the image of a flat Kansas.

Thus the particular mix of parent material with which the state was endowed, shaped by erosion and the climatic patterns of its midcontinent location, has produced a distinctive landscape. In the most general terms, it is composed of exposed, slightly inclined strata in the east forming cuestas or benches and slopes and, in the western half of the state, westward-inclined beds covered by rock and soil abraded from the Rockies over millions of years. Because the east was not covered by the debris from the Rockies, its exposed sedimentary layers have continued to erode, revealing the oldest rocks in the state. Together these dual geologic processes created a gradual upward slope, from a low elevation of about a thousand feet near the Kansas-Missouri border to slightly over 4 thousand feet atop Mt. Sunflower near the Colorado border.

Shoal Creek in Schermerhorn City Park, Ozark Plateau (Cherokee County)

Humans seem to have a need to categorize the natural world. This urge may be, in part, an attempt to define our place in the overall scheme of life, to identify where we fit in. Not suprisingly, since we are doing the classifying, we often end up at the top of the perceived pyramid of biological sophistication. We must realize, though, that most classification designs are one-dimensional and may not reveal accurate relationships. Without knowing the biology of amphibians, for instance, it would be easy to miss the fact that aquatic tadpoles are the same creatures as terrestrial frogs.

Classification is not, however, the simple gratification of a primitive urge. When rational criteria are used, a classification scheme becomes an effective tool for identifying a thing and placing it in context. When we classify a region, then, we provide clues to its origin as well as its affinities with neighboring regions, both near and far.

Scientists develop technical schemes to pigeonhole plants, animals, and rocks, but people often develop a local jargon to describe their regions. For example, a large area in north-central Kansas is designated the Smoky Hills region by geographers because of its association with the Smoky Hills and their drainages. Locals, however, tend to refer to parts of the region as Post Rock Country, a reference to the practice of using Smoky Hills Limestone as fence posts.

Classification schemes usually involve a hierarchy of categories. Kansas has been divided into eleven physiographic regions, which themselves are embedded in two provinces (Great Plains and Central Lowlands), which are regions of the Interior Plains, a larger division in the hierarchy of landform classification that describes the area between the Rockies and central Missouri and the Ozarks. A physiographic region, by definition, is an area consistent in its form and composition. In Kansas, the names of the eleven regions describe either their dominant forms or their geographic locations.

Ozark Plateau

If you were to grab the lower right corner of a road map of Kansas between your forefinger and thumb, the Ozark Plateau would lie just under your thumbnail. This 50-square-mile piece of a much larger province that extends throughout southern Missouri, northeast Oklahoma, and northern Arkansas just barely edges into Kansas. On its surface lie the oldest rocks in Kansas – cherty limestone and shale deposited in the Mississippian period over 330 million years ago. This layer was formed by the vast Mississippian sea that extended west into Montana and Wyoming 250 million years before the formation of the Rocky Mountains. These ancient beds contain the creatures of that time, fossil crinoids related to modern sea stars and extinct trilobites.

When the sea receded (about 330 million years ago), the freshly deposited limestone was exposed, briefly, before it was buried by thousands of feet of younger material. This limestone would be uncovered and re-covered three or four times, but in the process, it was fractured and filled in with material that, when leached for millions of years, formed extensive deposits of lead and zinc. Beginning in 1870 in Kansas, those deposits were commercially mined.

This particular limestone also contains vast quantities of chert, a hard flint that may be of plant origin, though the processes that generate chert are not clearly understood. Because this chert is significantly harder than the

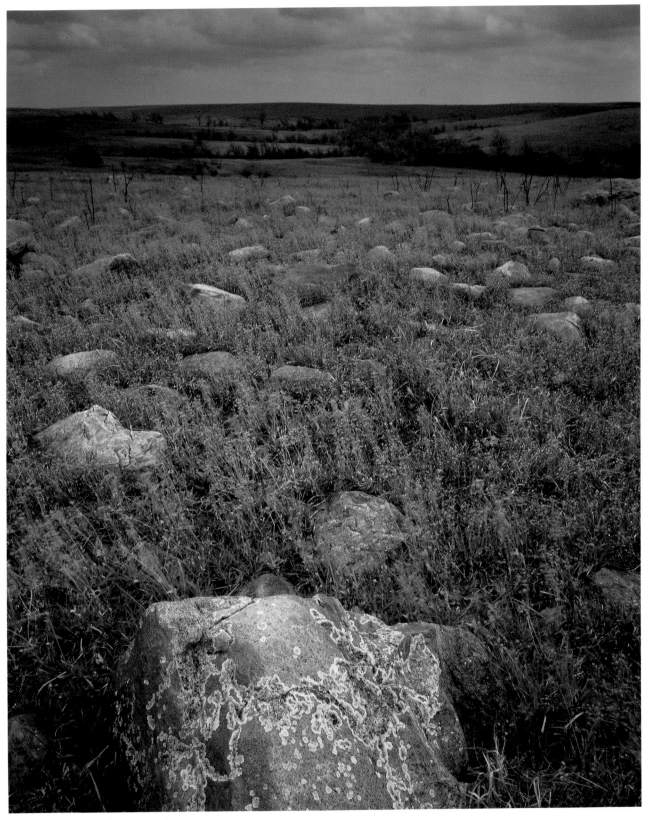

*These glacial erratics, large stones left when glaciers receded from Kansas, define the edge between the Glaciated
Region and the Flint Hills. (Wabaunsee County)*

limestone matrix, it persists on hill and ridge tops as the limestone erodes around it like the walnuts in melted fudge. The Ozark Plateau is famous for its caves, usually eroded or dissolved pockets in the limestone carved by moving water. Many become sinkholes when their roofs cave in at the surface.

Because the Ozark Plateau receives more rain than the rest of the state, it is a luxuriant, green landscape. Large, dense forests cover undisturbed hillsides and support an extensive undergrowth unique in Kansas. But only a small patch of this region reaches into Kansas, and some of that has lost its native features. Still, places like Schermerhorn City Park provide a glimpse of this distinctive landscape.

Cherokee Lowlands

Surrounding the Ozark Plateau, the Cherokee Plain is composed of shale, sandstone, and coal from the Pennsylvanian period. When one of the great sea invasions retreated at the close of the Mississippian, this region remained near sea level for many millions of years. Its proximity to the ancient seashore left it susceptible to inundation with slight rises in sea level, and even when it was above ground it was hot and swampy. These conditions were ideal for lavish production of plants (mostly ancient ferns), which then died and became buried in the oxygen-starved swamp bottoms. The addition of thousands of feet of younger sediments and millions of years of pressure converted these poorly decomposed layers into rich seams of coal.

The current landscape of the Cherokee Lowlands is dominated by the soft, easily eroded layers of shale and sandstone. Consequently, the landscape there is low and relatively level, with dreary, slow-moving streams meandering across its surface. It is quite productive, though, because of its high rainfall, so much of the land has been captured for agriculture.

Osage Cuestas

The majority of southeast Kansas lies in this physiographic region, except for the Ozark Plateau, the Cherokee Plain, and a few other small, embedded regions. The landscape here is typical of the general pattern in eastern Kansas, where alternating layers of sandstone, shale, and limestone are tilted slightly downward toward the west, exposing the harder edges of limestone to the east. The topography is reminiscent of the basin and range features of western North America but on a scale of several miles rather than scores of miles.

The rocks of this region are about 300 million years old, and their traits reveal that they were deposited on the shores of the great Pennsylvanian sea. In general, sandstones

are deposited along old river channels or in relatively shallow water, where they are subject to deposition from runoff; shales are formed in deeper water in the turbulent, muddy sea bottoms; and limestones are laid down in the deepest water, where the remains of calcareous animals accumulate. Thus, the particular sequence of rock layers – which tends to be sandstone, shale, limestone, shale, sandstone – suggests repeated incursions and recessions of the sea, produced by a cycle of shore, shallow water, deep water, shallow water, shore. The area must have been quite flat, and hence susceptible to flooding with only slight changes in sea level.

The assortment of soil types produced by these layers yield a diverse flora. The broad west-facing slopes of each cuesta tend to support plants with higher water requirements, while stony, dry, east-facing ridges offer a more tenuous perch for plants.

Chautauqua Hills

This tiny sliver of a region, only a few miles wide, extends like a finger north from the Oklahoma border for about 70 miles. Its location and its composition – thick layers of sandstone – indicate that it was once a major watercourse, emptying fresh water into the Pennsylvanian seas. It still provides a reliable source of water for the region's extensive groves of oaks.

Flint Hills

Just west of the Osage Cuestas are the younger Permian beds (240 to 280 million years old) that make up the Flint Hills, perhaps the most picturesque region in Kansas. Like the cuestas to the east, the Flint Hills are composed of multiple benches of limestone sandwiching softer shale layers. The result is the tiered, layered hills so characteristic of the area. Because the Flint Hills limestone is impregnated with flint, it resists the forces of erosion and persists in the form of high, flat buttes surrounded by sloped banks of shale.

It is on this distinctive terrain – and because of it – that the largest remnant of tallgrass prairie in North America survives. Elsewhere, much of what was once tallgrass prairie came under the plow, but here the chert-bearing limestone has protected the prairie from sod-busting. Furthermore, the Flint Hills have yielded only shallow soils – soils that early farmers found too shallow for most of their crops, except in bottomlands near rivers, and destructive to their valuable plows. Today the Flint Hills serve agriculture mainly as tallgrass pastures rather than as farmland.

One of the most important remnants of tallgrass prairie is the Konza Prairie Research Natural Area, a research preserve owned by the Nature Conservancy and managed by Kansas State University. Scores of long-term experiments conducted there examine the

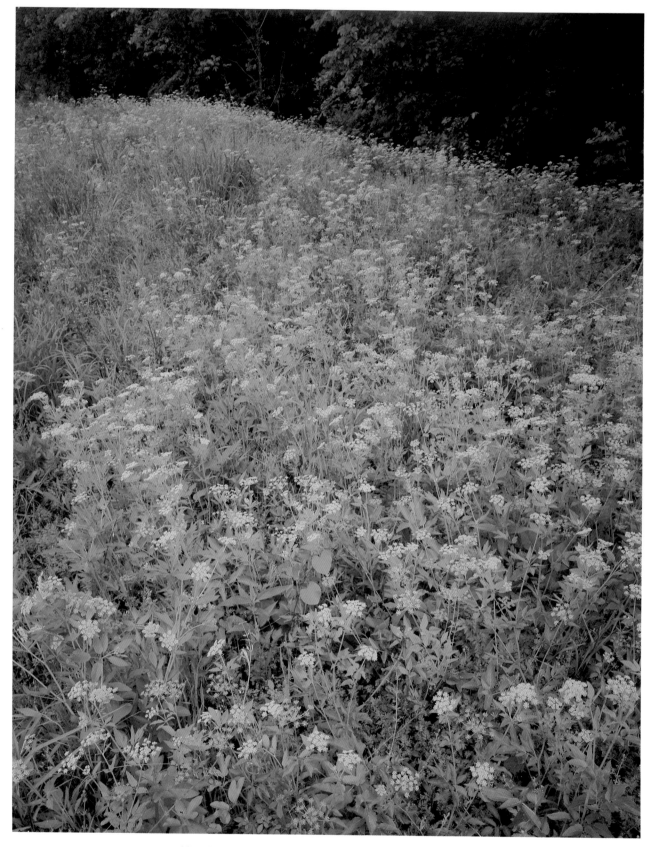

Golden Alexanders in an open glade in the Osage Cuestas (Woodson County)

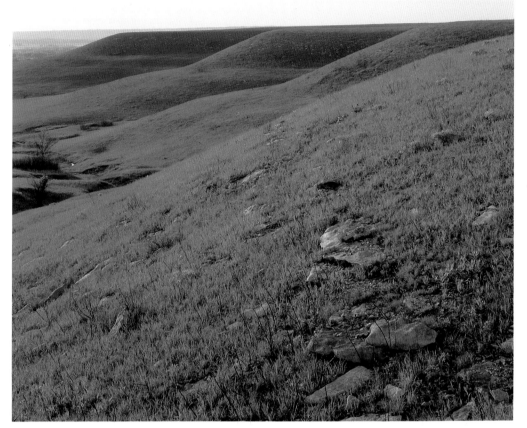

Benches and slopes of classic Flint Hills topography. These limestone ledges will gradually be uncovered by the erosion of the softer surrounding material, then degraded by persistent natural forces. (Konza Prairie, Riley County)

effects of fire and the impact of grazing by bison and cattle on native tallgrass prairie. Most of the preserve, south of Manhattan in Riley and Geary Counties, is reserved for research, but a nature trail is open to the public from dawn to dusk every day of the year. It offers visitors a close-up view of the tallgrass prairie as well as spectacular vistas of a habitat that once extended over much of the Midwest and Great Plains. Hundreds of plant species flourish here, of which 75 species are grasses, including the awe-inspiring big bluestem which can grow over 10 feet high in wet years.

Wellington-McPherson Lowlands

Southwest of the Flint Hills lie the Wellington-McPherson Lowlands, a small region similar in many ways to the Cherokee Lowlands, particularly with regard to the soft, easily eroded deposits from the Permian period. But these layers contain some limestone, and this minor difference provides slightly more variation to the landscape here than in the Cherokee Lowlands to the east.

Nearly every time the great seas of the Pennsylvanian and Permian periods withdrew to

the southeast, they left behind large inland pools of salty water that may have stretched over hundreds or thousands of square miles. Because they were shallow and broad, these pools evaporated quickly, concentrating salt and other minerals. After the region was covered by younger sediments, huge salt and gypsum veins remained among the shale and limestone. When the overlying beds eroded away, any salt (or gypsum, to a much lesser extent) on the surface quickly dissolved and ran off into streams.

Beneath the ground, though, these deposits endured, and many were mined. (Only two of these mines persist, one each in Barber and Marshall Counties.) Occasionally, a dissolved underground salt deposit settles and collapses into a sinkhole. In other instances the fractures caused by the subsiding surface fill with silt and clay, forming a sealed basin that may become one of the few natural lakes in Kansas.

This region is known for its low, slow rivers, such as the Chikaskia and Ninnescah. Though these watercourses have been abused along much of their length, there remain idyllic streamside spots in lowland riparian forests.

Red Hills

Stretching in a narrow band across four counties (Harper, Barber, Comanche, and Clark), the Red Hills are one of the most striking landscapes in Kansas – brick-red buttes of siltstone and sandstone deposits capped by an icing of white gypsum or dolomite, a layer formed by ancient limey mud.

Like the Wellington-McPherson Lowlands, the Red Hills resulted from marine lakes left behind by the retreating seas. But because they were farther west, the Red Hills received drier sediments from the beginnings of mountain building in Colorado. And in that drier environment, the silt and sand of the incipient Red Hills were oxidized and thus turned red, a color that characterizes Permian deposits all over the world.

Native Americans called these buttes medicine hills, and the Medicine River is the major drainage through the region. There may be truth to stories of their purported healing powers, too, since many of the creeks originate in the mineral-laden dolomite and gypsum layers at the top of the Red Hills and so contain solutions with some medicinal qualities. Magnesium sulfate, for example, is known commercially as Epsom salts and has been used medically as a purgative and to soak bruised muscles.

Several impressive sinkholes dot the western margins of the Red Hills, especially in Meade and Clark Counties. The largest, Big Basin, was formed when the dissolution of salt and gypsum several hundred feet below the surface caused the surface to sink over 100 feet into a depression more than a mile across. A somewhat smaller basin, Little Ba-

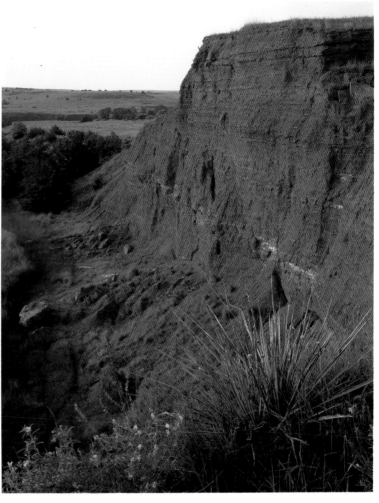

Brick-red shales and sandstones of the Red Hills region (Barber County)

sin, lies less than a mile to the east of Big Basin and is punctuated by St. Jacob's Well, a small spring in an emergent limestone layer.

For the traveler, the large sinkholes create a sensation that is rare in Kansas, that of being on an edge. Because they are surrounded by relatively flat land, sinkholes are usually undetected until the last moment. Then suddenly the nearby ground opens to a canyon-like vista, and the mind's eye must recalibrate its scale of perception.

Arkansas River Lowlands

This region has been one of the most dynamic areas in the state, geologically speaking, and its enterprise continues. The Arkansas River originates in the Rockies, where it is responsible for carving the Royal Gorge through the eastern flank of the mountains. The cutting power of this river in Colorado is sharpened by its steep descent, but once it gets

Winter sky over the Red Hills in southern Kansas (Barber County)

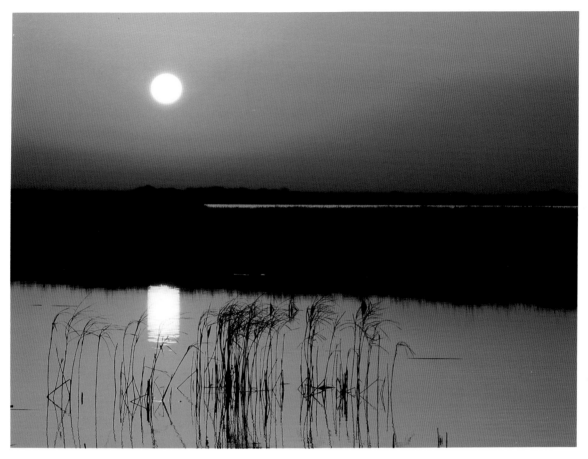

Sunset over Cheyenne Bottoms at the northern edge of the Arkansas River Lowlands (Barton County)

to Kansas its wild ride is over. It becomes a sedate, almost imperceptible flow, and even disappears in spots. However, it still makes withdrawals from the western slope of the Rockies and deposits them in the sandy banks of Kansas.

The outline of the Arkansas River Lowlands defines the past and present flow of the river. Slow-moving rivers in relatively flat country tend to meander back and forth over the landscape, sweeping a broad path of influence over time. Currently, the Arkansas River is about as far north as it has ever flowed, so broad areas to the south are covered by hundreds of feet of sand and silt deposited by the Arkansas in the last several million years.

The region serviced by the Arkansas River is an area of grass-covered sand dunes sometimes known as the Great Bend Prairie. (The town of Great Bend is located on a prominent crook in the river where it curls north before winding back to the southeast.) Cheyenne Bottoms, one of the most important wetlands on the continent, is located just north of the river's northernmost point. The varied geologic history of Cheyenne Bottoms suggests that it may have served as a knuckle, yielding the bend in the river.

Smoky Hills

These hills, lying in a broad, dissected plateau in the central third of the state, are among the most beautiful and interesting in the Great Plains. They are composed of Cretaceous deposits, both marine and terrestrial, and contain intriguing fossils. Unfortunately, the gap in time between Permian to Cretaceous rocks leaves out about 80 million of the most interesting years on the planet – the Triassic and Jurassic periods – when dinosaurs ruled the earth. Rocks from these periods were either never deposited in Kansas (although a small Jurassic system is present in deeply buried strata in western Kansas and another crops out in Morton County) or were eroded away after deposition.

These are the technical details of the Smoky Hills, but their impact on our senses is much more sublime. Here travelers coming from the east first meet bluffs that run east to west and canyons that lure them along, rather than the bench-like hurdles they must cross farther east. To me, this is where the West begins, as one yields to a landscape beckoning westward, rather than to the east.

Three prominent layers of the Smoky Hills region are exposed on the surface, beginning with the Dakota Sandstones. These limestones are the oldest and farthest east of the Smoky Hills layers, and they are responsible for many distinctive buttes on the eastern flank of the Smoky Hills. Such prominences, visible from great distances, served as guideposts to early settlers and sentinel stands for Native Americans, Coronado's troops, and early American settlers.

The Dakota Sandstones were deposited when Kansas was the coastline of a sea intruding from the northwest. At that time, the lands west of Kansas began to dip in that direction, allowing the sea to flow in and stretch from Montana south across the continent. The resulting deposits were not tidy like those of the Flint Hills, but chaotic, filled with a variety of materials. Often they exhibited crossbedding (tilted, intersecting layers), which indicates a rapidly fluctuating environment and movement of surface material. The only two dinosaurs found in Kansas, a primitive, lumbering plant eater and a duck-billed form, occur in these terrestrial deposits.

Farther west and in slightly younger deposits lies the Greenhorn Limestone. This formation is primarily shale, but one particular limestone layer, the very top one, is renowned for its usefulness. Uniformly about one foot thick, it is soft enough to be quarried and sawed, but can be cured in air and sun to long-lasting hardness. This is the noted fence post limestone. It has been used extensively for construction and fence posts in a region almost bereft of usable timber.

The third major component of the Smoky Hills is the Niobrara Formation, made

Facing page:
Remnants of thick
layers of Dakota Sand-
stone, Rocktown Natural
Area (Russell County)

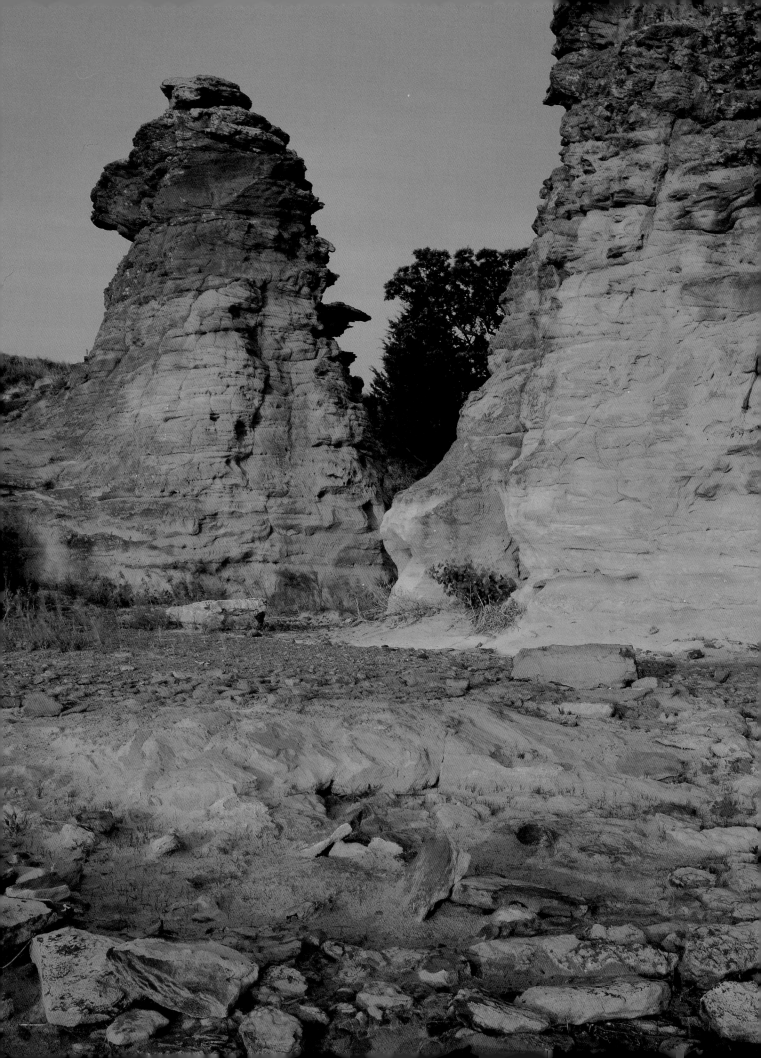

from extensive marine deposits laid down while western Kansas was under a very large sea that stretched southeast from Alaska to the Gulf of Mexico. Though the sea eventually drained to the west as the Rocky Mountains rose, it was responsible for the accumulation of vast quantities of limey plant and animal carcasses that eventually became the chalk beds of the Niobrara Formation. Embedded in these strata are some of the most renowned fossil vertebrates found in North America, including fish, plesiosaurs (marine relatives of dinosaurs), and gliding pterosaurs.

The Smoky Hills contain a broad, shifting contact zone where components of the tallgrass prairies to the east and shortgrass prairies from the west interact, yielding the distinct amalgam of the mixed-grass prairie. This vegetation, coupled with the sublime topography of the Smoky Hills, makes the region among the most beautiful in midcontinent.

High Plains

The western quarter of Kansas is dominated by vast accumulations of material eroded from the rapidly forming Rocky Mountains. These Tertiary deposits, torn from their source to the west and washed or blown east over a period of 60 million years, formed a deep mantle of sand and silt that spread like a giant skirt from the foothills into the adjoining states. The portion that extends into Kansas lies at the center of the huge alluvial delta of debris spreading from the central Canadian provinces to Texas.

Undisturbed, this delta would have developed a fairly uniform eastern edge, but the very rivers that carried a majority of the material into Kansas also dissected its surface, producing finger-like interdigitation with the marine deposits of the older Smoky Hills region. Many of the main roads in Kansas follow the tops of these eastward-projecting fingers, giving the impression to the casual visitor that this is a numbingly flat region. However, short side trips north or south reveal the cuts and draws of past and present watercourses. All of the rivers and streams flowing from Colorado into Kansas today, particularly the Arkansas and Cimarron, continue the ancient process of moving the earth's material downhill with the unintended consequence of leveling the landscape.

Glaciated Region

Generally, the geologic pattern puts the oldest rocks in the eastern part of Kansas, but this pattern is interrupted where glaciers intruded in the northeast corner of Kansas. The glaciers that penetrated Kansas formed during the last 2 million years, when cyclical episodes of cold winters caused huge accumulations of snow and ice in the northern fringes

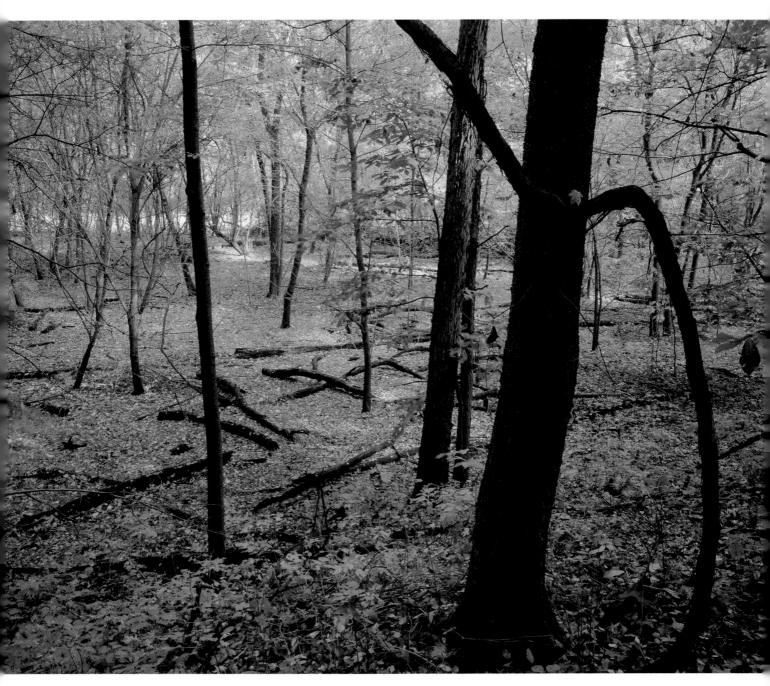

Missouri River bottoms in the Glaciated Region of northeastern Kansas. Note the sparse understory and ground cover under the heavy forest canopy. (Leavenworth County)

of the continent. As the ice accumulated, its pressure on the bottom of the ice pack caused the glaciers to gradually ooze south. The first glacial invasion, the Nebraskan, barely made it into Kansas, but the second major advance came far enough south to be dubbed the Kansan. It terminated just east of Manhattan, where its 2-mile-high leading edge nudged the Kansas River south of its original path.

It is difficult to imagine a glistening chunk of ice 10 thousand feet high, but there are ample clues that such a sight existed. As the glaciers moved south, they plowed in front of them billion-year-old rocks from southern Minnesota and South Dakota, then retreated, abandoning the rocks where they lay. The boulders left behind were the lucky ones, since those that got plowed under the ice were turned to rock flour, extremely fine powder that blew or washed hundreds of miles and created deposits over a hundred feet thick along the Missouri River in Doniphan County.

Northern habitats, like northern rocks, were also nudged ahead of the advancing glaciers. Forests, some of which are characteristic of the boreal areas of Canada today, moved south into Kansas. They brought with them many of the forest animals of the time, including large moose, deer, musk oxen, camels, mammoths, mastodons, and saber-toothed cats. These creatures retreated back north with the receding glaciers and their associated habitats, but their bones regularly emerge from road cuts and riverbeds in Kansas. In geologic time, these events are recent history – recent enough, perhaps, to make us sorry we missed this icy spectacle. Luckily – or unluckily – we may get another chance. Since the cycle of glacial intrusions appears to be unfinished business, Kansas may again experience an ice age.

GEOLOGIC ODDITIES

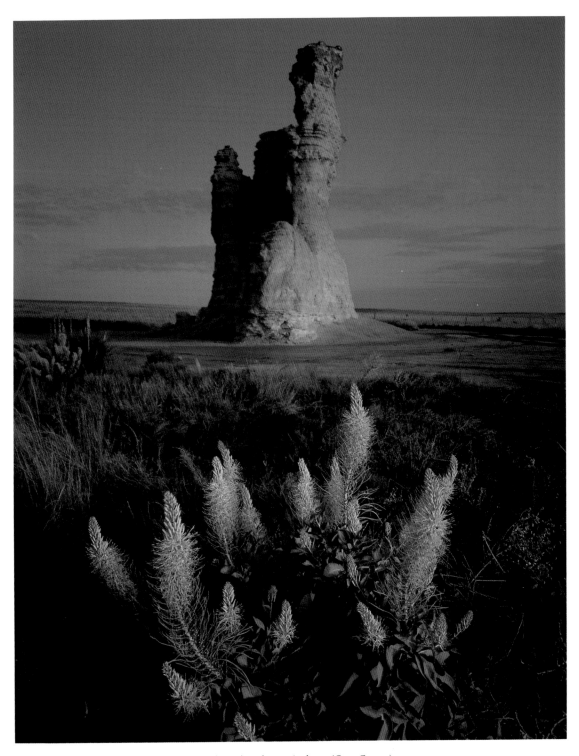

Castle Rock and Prince's plume (Gove County)

Vast areas of Kansas – thousands of square miles – consist of relatively uniform habitats. A third of the state sits within the High Plains physiographic region and perhaps a fifth in the Smoky Hills province. Even the smallest region, the Ozark Plateau, is larger than 50 square miles. Within these regions the landforms vary only a bit, mostly where streams and rivers etch their courses through multiple layers of stone. But within these uniform regions are geologic oddities, the result of either particular past events or unique contemporary circumstances that carved them from their ordinary surroundings much like a sculptor extracts a figure from a slab of marble.

These distinctive elements often served as guideposts to the early settlers as they moved across land that appeared featureless. Rather than simply heading west – "out there somewhere" – travelers could steer for Monument Rocks or Castle Rock. In some cases, such as St. Jacob's Well, the oddities were oases, providing shade and water for weary wagoners. Even today these areas, many of them quite small, are alluring. Like our predecessors, we visit them and wonder how they were formed when all around them the land appears deceptively homogeneous.

Perhaps the most distinctive of these odd features are the elegant sentinels of chalky limestone that stand watch over west-central Kansas. It takes no more imagination to visualize these pinnacles from their names – Castle Rock, Monument Rocks, Cobra Rock, Elephant Rock, Mushroom Rocks, and Rock City – than it did to name them in the first place. But by naming them, settlers recast them as familiar figures in a vast and unfamiliar expanse of plains.

Castle Rock, Monument Rocks, and Cobra Rock consist of erosion-resistant limestone caps supported by 25- to 70-foot columns of chalk from the Niobrara Limestone. This material is quite soft and has completely eroded away wherever it has been exposed to surface conditions. For hundreds of square miles around these monoliths the chalk has disappeared, but under their protective caps, they persist.

Even with their limestone helmets, though, the monuments are eroding at a pace detectable within a few decades. Some of this erosion is natural, and it is exciting to imagine the transformation of such noble structures within one's lifetime. Unfortunately, though, their erosion is being hastened by the unconscionable activities of people who drive all-terrain vehicles on the delicate chalk buttresses and blast away pieces with firearms. These formations are true monuments to spans of time and geologic forces almost beyond our conception; their accelerated demise is a monument to our insensitivity and lack of respect for our elders in the natural world.

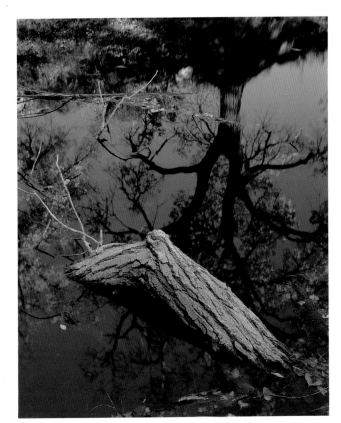

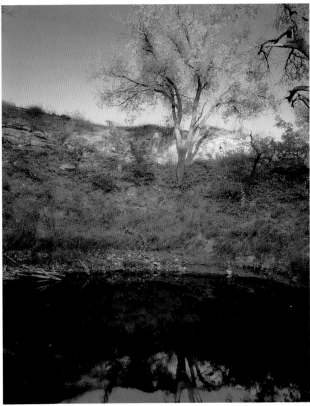

Reflection of a cotton-wood tree pierced by an emersed cottonwood branch, St. Jacob's Well (Clark County)

St. Jacob's Well, a sinkhole in the Big Basin Prairie Preserve (Clark County)

Farther east, in somewhat older strata, lie Rock City and its orphaned companions 30 miles to the south, Mushroom Rocks. At Rock City, in Ottawa County, scores of sandstone spheres, some more than 25 feet in diameter, lie in disarray on the surface, flushed from the surrounding earth by differential erosion. The rocks at Mushroom Rocks are also round, but because erosion is further advanced than at Rock City, the spheres are elevated on bases of poorly cemented sandstone.

These sandstone spheres were formed when calcite crystals grew out in all directions as water circulated through the porous sandstone layers of the Dakota Sandstone. When the material dried, it left sandstone nodules that were significantly more resistant than the matrix in which they were embedded. Wind and water, with an assist from time, wore away the surrounding material, leaving these megamarbles exposed. They are interesting in their own right, but they also reveal an extensive pattern of crossbedding. The environment in which they were produced was dynamic, and the thin lines of sandstone lying at obtuse angles to each other testify to the vigorous aquatic forces at work millions of years ago.

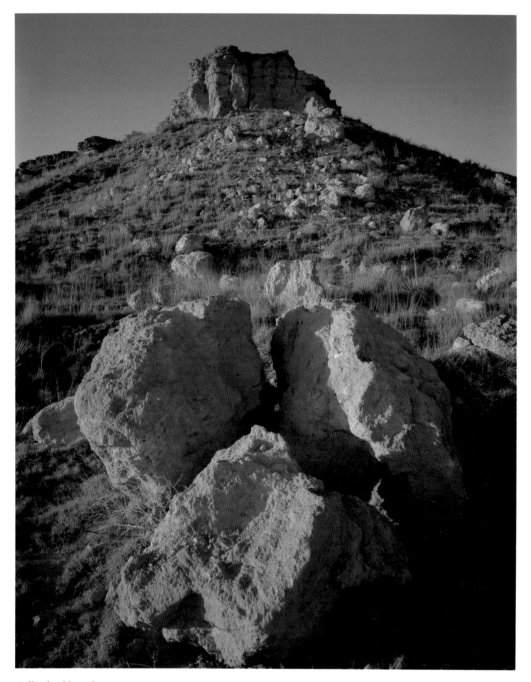

Fallen boulders of Ogallala Sandstone at Point of Rocks, a guidepost on the Santa Fe Trail (Morton County)

Sinkholes and caves take the opposite geologic route – rather than sticking up out of the ground, they are the product of below-ground processes. Sinkholes form when caverns grow inside the earth through the dissolution of underlying material. When the cavern gets large enough, and the overlying burden great enough, the surface collapses, forming a fairly symmetrical depression or basin. In some cases the drop may be quick

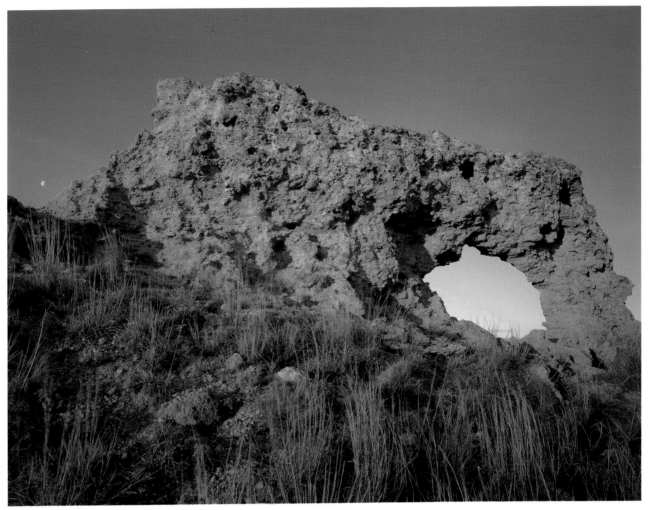

Elephant Rock
(Decatur County)

and dramatic, perhaps even penetrating to the cavern itself and leaving a gaping hole into the abyss. More often, the subsidence is gradual, leaving a depression that may eventually seal itself with surface deposit and become a lake, until it fills with sand and silt and finally disappears.

Caves in Kansas are primarily formed in gypsum and limestone and are the result of water flowing below ground. Limestone is highly fractured and water easily percolates through the cracks. It may accumulate in underground rivulets that flow into streams and rivers, just as water on the surface coalesces into larger and larger flows. The water eventually erodes or dissolves its own route through the limestone, and where it exits the underworld to the surface, it may be discovered as a cave.

The real wrinkles in the landscape – the features that deliver Kansas from the dreary

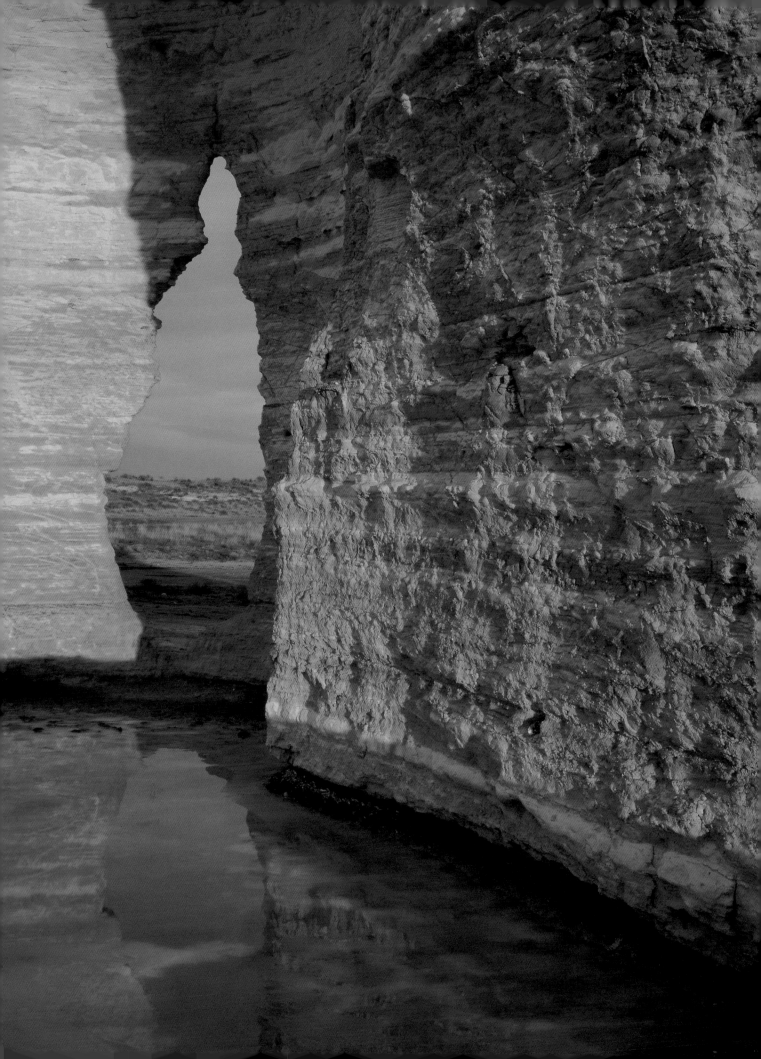

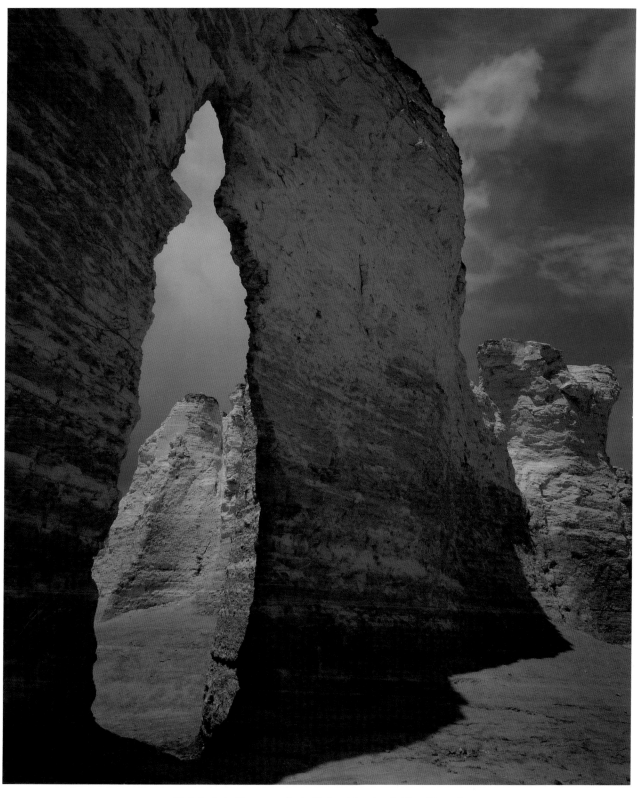

Keyhole Arch, Monument Rocks National Landmark (Gove County)

Facing page: Sunset at Keyhole Arch, Monument Rocks National Landmark. At one time the small aperture at the top was separated from the larger opening below, but erosion and vandalism have obliterated the intervening chalk. (Gove County)

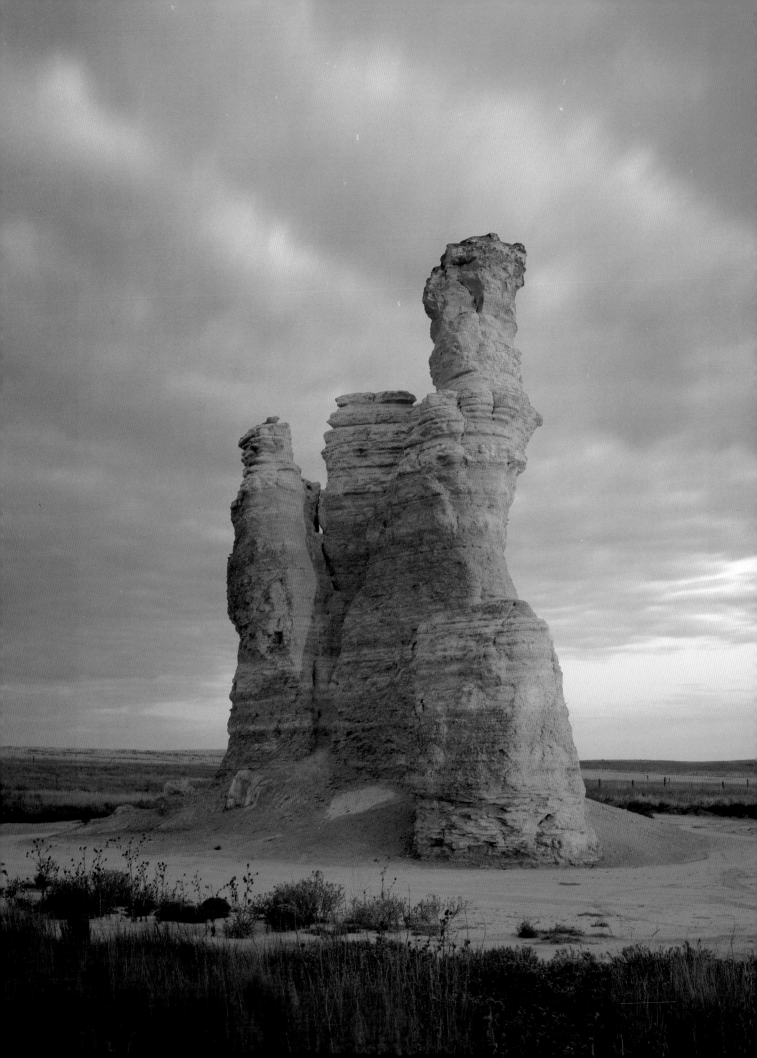

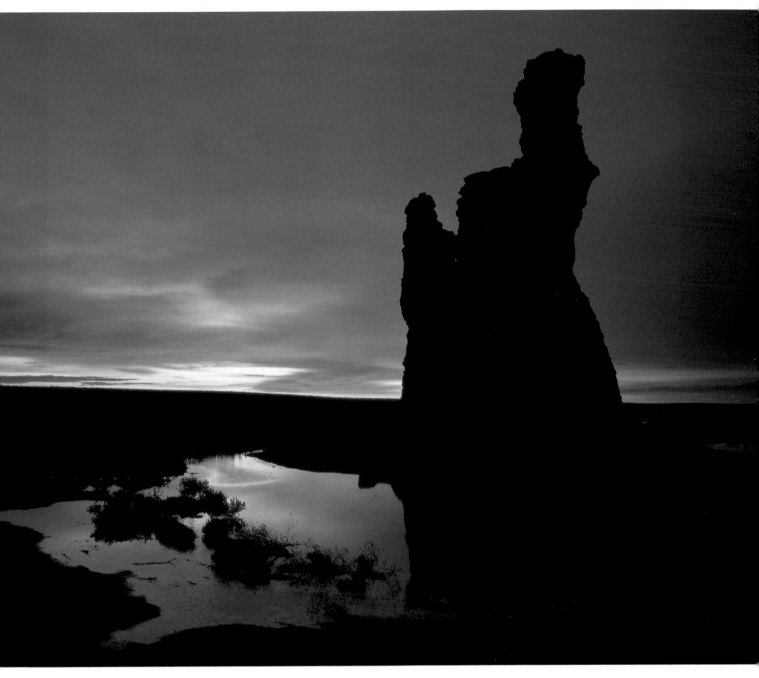

Sunset behind Castle Rock (Trego County)

Facing page: Dawn over Castle Rock (Trego County)

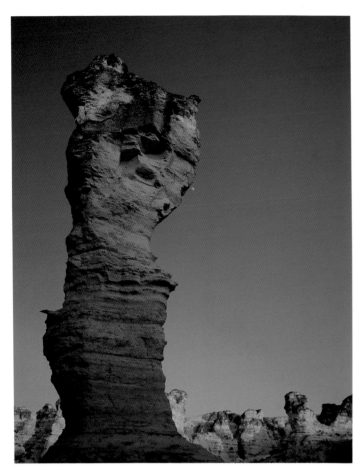

Cobra Rock, an isolated pinnacle similar to those at Monument and Castle Rocks (Gove County)

flatness most people seem to expect – are the irregularities in the crust associated with surface erosion. These occur everywhere on every scale. Stand on any soil in Kansas (and virtually anywhere else) and look down at the ground around your feet. You will see small discontinuities in the surface. These may be caused by the footprints of animals, emerging vegetation, wind, or water, or they might simply reflect the rough texture of grains of sand fitting imperfectly together. Regardless of their origin, these irregularities become the focus of the next storm. When rain next pounds the ground, it will seek the path of least resistance and move downhill through these spots, forming miniature rills. As the water coalesces and its power increases geometrically, it carries larger loads of sediment, knocking the existing debris aside and abrading the earth's skin. At the smallest scales these water tracks are ephemeral and easily rearranged second by second as water or wind swirls through them. As they cut deeper, though, they become entrenched trails that the next flow will follow, eventually establishing a dendritic pattern of draws and canyons.

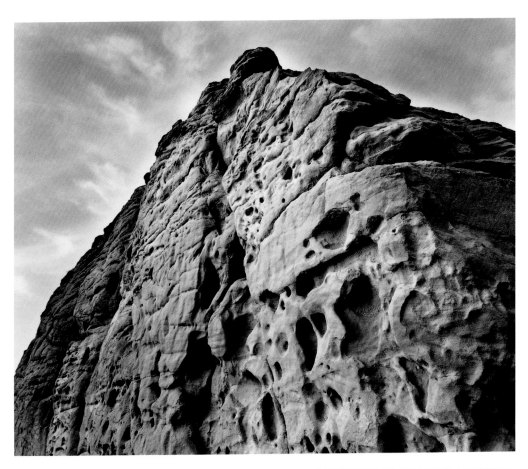

Rock Town
(Russell County)

Elephant Rock on the
horizon (Decatur County)

Sandstone concretions at Rock City (Ottawa County)

A rock on its pedestal at Mushroom Rocks (Ellsworth County)

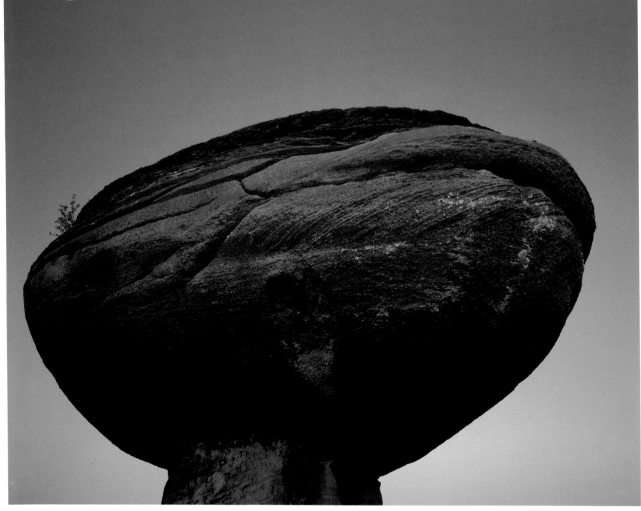

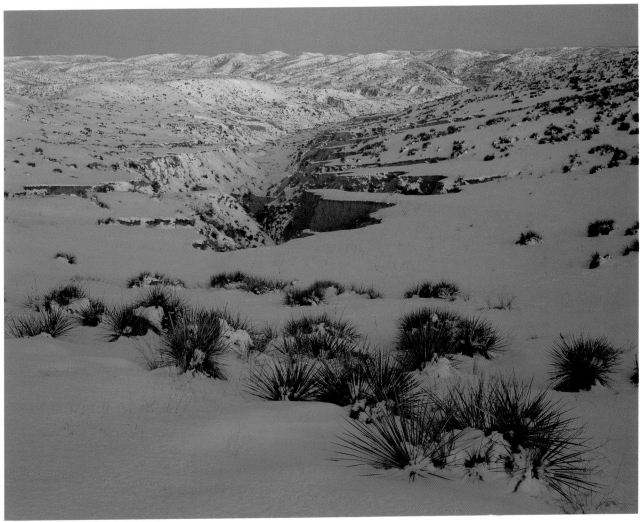

Eroding canyon along the margins of the Arikaree Breaks in northwest Kansas (Cheyenne County)

Where particularly resistant stone is exposed, or where water falls in diverse soils, regions known as breaks may form. Breaks present a wide array of microhabitats where distinctive plant and animal communities develop. If the draw happens to run east to west, the south-facing slope will always be exposed to the relentless sun and become baked and arid. The shady north-facing slope will be cool and moist and support a distinctive complement of vegetation. Both slopes are precarious haunts, however, as they will succumb quickly to the constant forces of weathering.

These Kansas breaks are not the awesome trenches of the far West. Here these canyons are small, and once again, we must look into them rather than at them to appreciate their specific qualities. At places such as the Arikaree Breaks in far northwest Kansas, for example, the land appears to have melted away, leaving a dissected surface like the crust of a loaf of homemade banana bread.

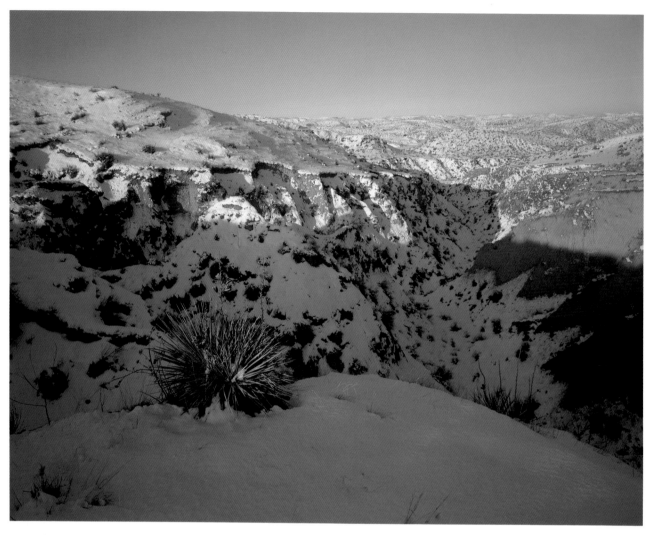

Snow in the heart of the Arikaree Breaks, with yucca in foreground (Cheyenne County)

VEGETATION

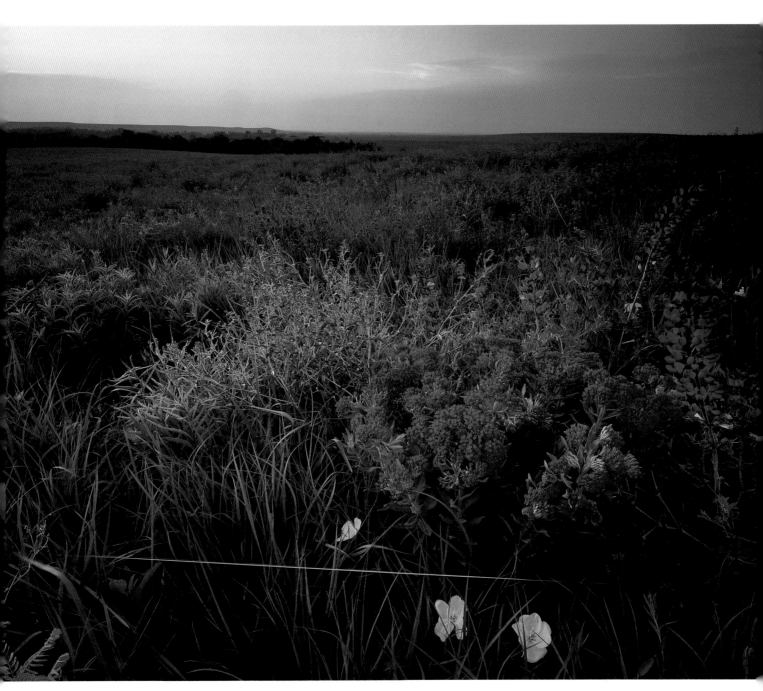

Butterfly milkweed and primrose in the Flint Hills tallgrass prairie (Butler County)

Even though its underlying geology sets the form of the Kansas landscape, what is most immediately visible when we scan the landscape is its heavy patina of vegetation. We tend to notice the vegetation first because it obscures the underlying soil, but perhaps more important, because plants grow more or less to human scale. Even the tallest trees barely reach higher than our homes, and most roots extend no farther than it is possible to dig with a shovel. Plants also signal the seasons, marking the cadences of autumn, winter, spring, and summer. And of course plants are food, a life-giving resource to us and to much of the natural world around us.

Though this perception may seem to make light of our dependency on the earth, it is, at least in part, a valid way to view and even to categorize the landscape. Plants, especially communities of plants, represent a long-term integration of soil types and climatic conditions, and over time demonstrate the type of plants a particular region can support. If we laid a map of the physiographic regions of Kansas over one showing its vegetation, we would be able to detect a congruence that is not simply coincidental in nature. Plants face an array of soil types and climatic conditions in Kansas (particularly unpredictable rainfall), and only those plants best suited for a particular combination of such variables will persist and flourish.

Often the success of an individual, a population, or a community is based on the overriding physical features of the environment. Where salt is a major component of the soil, plants that can cope with its effects will succeed. Where rainfall is scarce, or comes at unpredictable intervals, drought-tolerant species may be favored. Accordingly, over many generations, each physiographic region tends to develop its own indigenous citizenry.

This phenomenon is not simply a matter of xenophobia on the part of the plants. Even though adult plants tend to stay put (except for the ubiquitous tumbleweed, which employs wind power to propel it along the surface), the seeds of some species disperse hundreds of miles. Fruits may be consumed and transported by birds before passing through their digestive systems, or wind-dispersed seeds may blow scores of miles before settling to the ground. But once they are on the ground, they must compete for the limited resources with specialists from that area – those plants that have already proven they can succeed under those particular conditions. So even though individual plants are always trolling for new places to send their offspring, the great variety of environmental conditions conspire against them.

Clearly, dispersal works, for the vegetation of Kansas is almost entirely derived from other areas. The climate of Kansas has been as it is today for only 5 thousand to 10 thousand years. As the last glacier retreated it took with it remnants of the forests that had accompanied it south. Kansas then returned to a climate more characteristic of the

Facing page: Sumac and prairie grasses in autumn (Cherokee County)

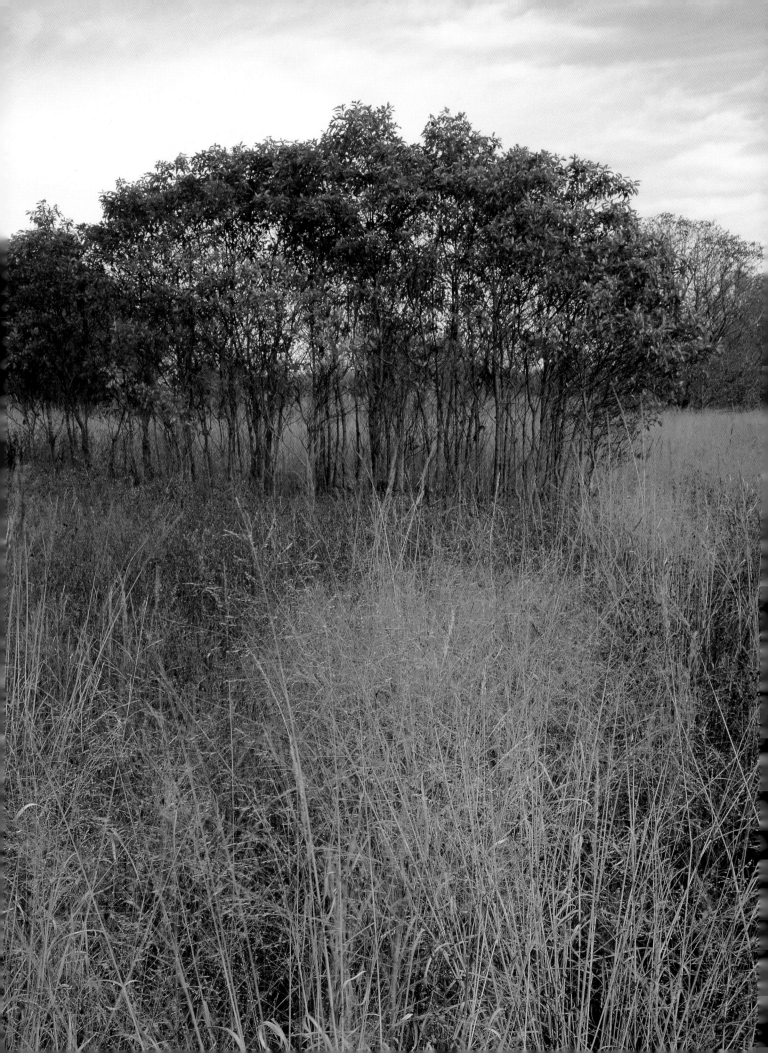

Flowering bramble
(Shawnee County)

midcontinent, and the race was on to take advantage of the newly available real estate. Seeds and fruits of plants in adjacent areas were carried or blown into Kansas, and early arrivals took root.

Seeds have a better chance to be successful early in the colonization process. All they need is a bit of open ground where they can put down roots and a window to the sky for the sun to shine through. In the moist areas of Kansas, space may be available in a rapidly

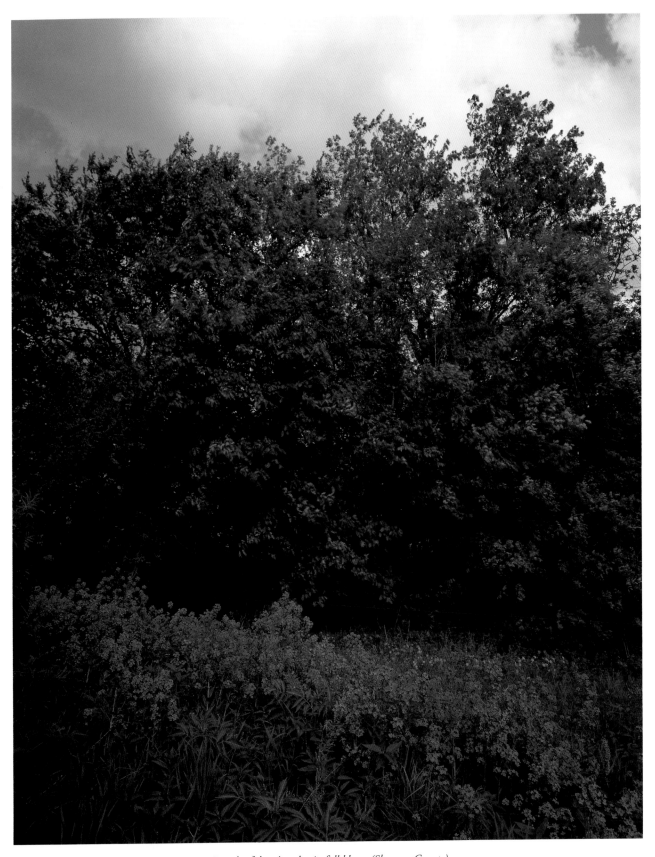

Cascade of dame's rocket in full bloom (Shawnee County)

changing or highly disturbed habitat. But once a plant community matures, there is very little room for invasions, and the seedlings that manage to germinate are often shaded out by taller competitors. In drier regions, where space may not be a problem, competition for moisture may set the rules of engagement.

Competition – the one-on-one, hour-by-hour tussle for resources – is a major factor structuring natural communities. The dominant resources for plants are light, water, and nutrients, especially nitrogen. Across Kansas, the availability of water forms an east to west gradient that significantly affects the vegetation. (The availability of sunlight and nitrogen are less variable, and more predictable, than rainfall.) In the east, where rainfall is greater than evaporation, the major competition is for sunlight. Accordingly, the eastern plants tend to be tall (trees) or to grow in places where they can pilfer a few photons, at least seasonally. For example, they may grow in breaks in the canopy along rivers and streams, or emerge early in the spring before the deciduous trees have leafed out. In the west, where space is abundant and water scarce, the plants are low and their roots penetrate to great depths in search of moisture.

Across large areas of Kansas the soil, which is an important component of any terrestrial plant community, has become sod. Soil is basically the dirt surrounding plant roots, along with miscellaneous chemicals, some of which are used as nutrients by the plants. In sod, this earthy matrix is held in place with a mesh of roots and other living matter. Where soil can usually be sifted through a person's fingers, sod must be pulled up like carpet.

The prairie is both responsible for and dependent on sod. The fine roots of grasses provide the soil matrix with a framework, and subsequently, grasses and their attendant forbs contribute to the maintenance of the unique miasma. When the soil is disrupted, alien "weeds" can invade and take up residence until the sod re-forms. Some important elements of the sod-forming process can be accomplished in 20 to 30 years, but a mature sod may take centuries to perfect.

Again succumbing to the need to categorize and classify, scientists have produced scores of maps showing the exact boundaries between soil types, physiographic regions, and plant communities. But even the most avid classifier recognizes that few of these boundaries actually exist, and those that do – such as the boundary between the terrestrial habitat and the stream – are trivially obvious. If you went to the exact spot where the map shows that the Wellington-McPherson Lowlands become the Red Hills, you could not straddle a line between the two. Nor could you step from the tallgrass prairie directly into mixed-grass prairie. Instead, these boundaries are transition zones, where the relative proportions of various plant species change, usually gradually and almost imperceptibly.

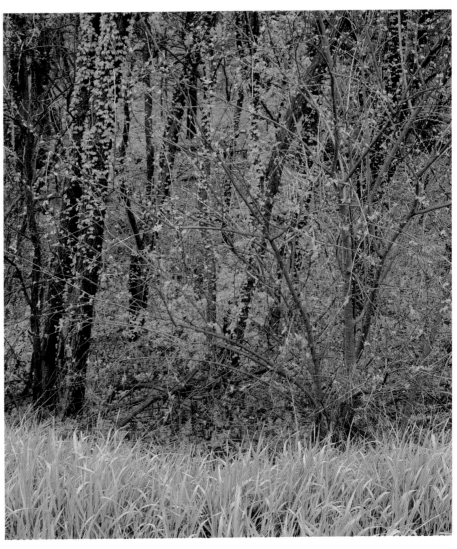

Mulberry breaking bud early in the spring along the Missouri River bottoms (Doniphan County)

These transition zones or edges are particularly interesting and productive spots, because there the distinctive components of adjacent areas intermingle.

These climate- and soil-induced transitions form long, sinuous, fluctuating borders between major habitats and add to the diversity of life. But perhaps even more significant are the millions of small patches and disturbances that dot the landscape and produce edges on a tiny scale. Mounds of dirt thrown up by a badger excavating a ground squirrel burrow, for example, or hollows dug by bison wallowing in the mud, produce microhabitats that specialists among the plants and animals seize upon. Without these small disturbances, the biota of a region would tend to homogenize and the dominant forms, which are ordinarily no more than 10 percent of the total inventory of organisms in an area, would eventually take over. These small nicks in the landscape are toeholds for the subor-

Beads of coral berry fruit, late summer in Happy Hollow (Shawnee County)

dinate species, allowing them to wedge in and take advantage of a spot where they can be more successful than their competitors. Where once such patches were viewed as true "disturbances" – stains on the carpet of the landscape – they are now credited with creating most of the diversity of life.

As with the boundaries between habitats, plants and animals take advantage of the transitions between time periods – between day and night or between the seasons. Like their spatial counterparts, these temporal transition zones are also broad and gradual. There is no single day, the equinox notwithstanding, when fall arrives. Instead, there is a gentle sense that the sun is lower in the sky, the days are shorter, and the breeze is cooler as

Deep oak-hickory forest in Breidenthal Reserve. In the background is the lower edge of the canopy, and the mass of vegetation in the middle is the understory. The foreground is dominated by a carpet of ground cover. (Douglas County)

it becomes more northerly. Nor does the night arrive abruptly when the sun goes down. Perhaps three-quarters of an hour after sunset the sky begins to get dark, and an hour later night arrives. But there is no single moment when day turns to night.

Certain plants, such as the evening primrose, take advantage of cool periods when they lose less water to evaporation, or when their pollinators are most active. Crepuscular animals, those active at dawn or dusk, are usually either seeking prey active at that time or trying not to become prey themselves by offsetting their activity periods from those of their predators. On a seasonal scale, migrating birds arrive and depart on schedules that match the resources available, and plants flower when the combination of temperature, moisture, and pollinators is optimal. This requires exquisite timing, but being wrong – flowering when there are no bees or when there is no wind to carry the pollen – often has fatal consequences.

PRAIRIES

"Kansas" means "prairie" to many people. Traveling east to west across the continent, one first gets the sense of being in the prairie in the eastern third of Kansas. From there, the vast inland sea, which must have been as daunting to early European visitors as the Atlantic was to their ancestors, stretches at least to the horizon (although one's intuition counsels that it goes well beyond). Before the region was settled, there must have been a point at which, when peering west, no trees could be seen, while a short distance to the east thick forests dominated that landscape.

Prairie, the French word for meadow, has come to be synonymous with grass. We think of Kansas as the prairie state, but only about 15 percent of the plant species in the prairies of Kansas are grasses. Pound for pound, though, grasses rule the prairie. In an average year more than 20 tons of fresh plants, mostly grasses, can be produced on one acre of tallgrass prairie, and in spectacular years the total may be 30 percent higher. This total may include over a million grass shoots (termed tillers) and 160 thousand flowering stalks of big bluestem alone.

Beyond their mere presence, grasses play a striking role in the biotic processes of the region. Because of their particular growth form and modes of reproduction, grasses are well suited to handle the prairie's triple threat: drought, fire, and consumption by grazers. These forces have shaped the evolution of grasses and their success in semiarid, mid-continental regions around the world.

Facing page:
Crisp autumn day
on Konza Prairie
(Riley County)

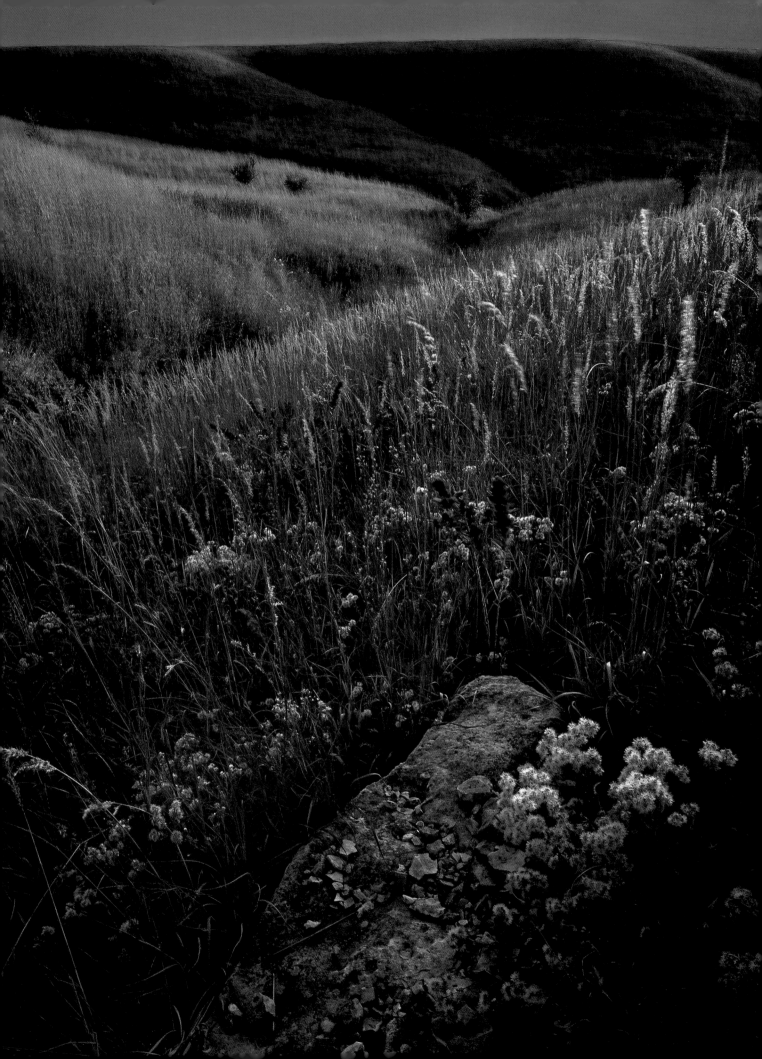

A sample of the diversity of plant life among the tall grasses, particularly big bluestem, of Konza Prairie (Riley County)

The key to the success of grasses in confronting these threats is that their growth tissues lie at or below ground level. Most plants grow from the tips of their branches and stems, leaving them vulnerable to damage. Grasses, however, telescope up from a growth point, or meristem, that is below ground and thus insulated from the above-ground danger. Consequently, they are less susceptible to damage from fire and grazing than plants that need their above-ground tissues in order to reproduce themselves. Drought, too, can severely debilitate most plants, because it dehydrates and kills all of the tissue above ground. Grasses can lie dormant for years, then produce leaves when conditions improve. We take advantage of this feature in our lawns: we regularly mow the grass, but we know we cannot do the same to our vegetables or flowers.

Not only can grasses survive grazing and fire, they may need them. Grazing animals recycle nutrients through their guts and trample the standing grass stems down to the soil surface, where microbes and tiny animals decompose them, releasing their nutrients into the soil. Fire also recycles nutrients and tends to eliminate the competition – trees and other flowering plants – that cannot cope with the damage as well as the grasses.

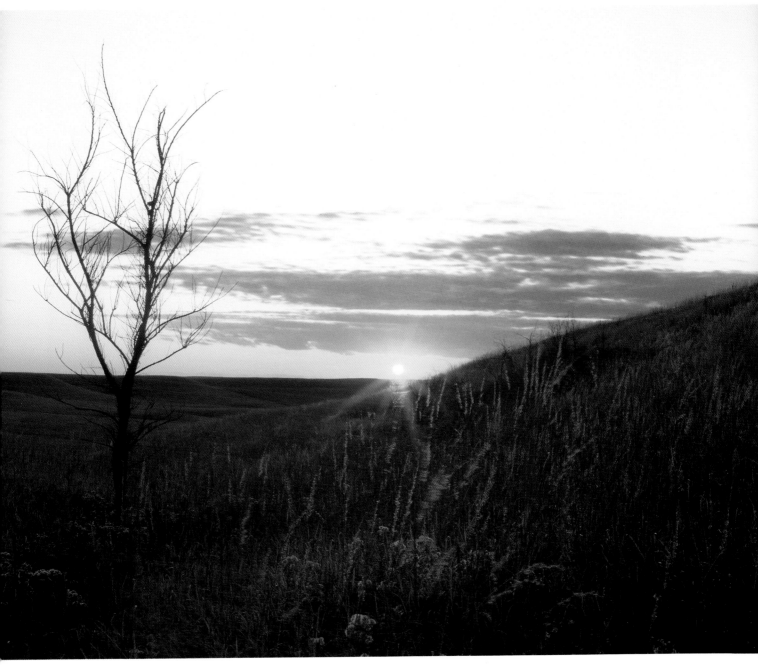

A tree snag, remnant of an early-season fire, silhouetted against a fall sunset on Konza Prairie (Riley County)

In addition to protecting their growing tissues below ground, grasses also develop a more extensive root mass that is less susceptible to drought. In dry periods, then, a grass plant can cut its losses and wait. Seasonally, grasses such as big bluestem withdraw 60 percent of their nutrients into rhizomes, horizontal underground stems, storing the nutrients for use during the next suitable growing season. Many grasses are long-lived peren-

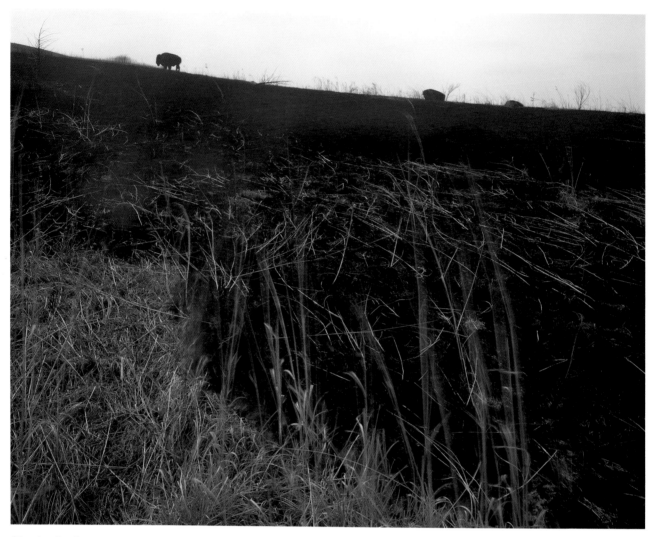

This slow fire, burning into the wind, has consumed the bases of standing dead stems of big bluestem, causing them to topple downwind, in the direction from which the fire came. Bison on the horizon appear oblivious to the fire. (Riley County)

nials capable of surviving numerous episodes of environmental harshness that would exterminate poorly adapted plants. But grasses have evolved ways to protect themselves from immediate danger and preserve their capital for future investment in offspring.

A second feature of grasses that promotes their success on the prairies is their reliance on asexual reproduction. Many prairies, especially those in the eastern part of the state, are quite crowded. There is little space for a seed to find an open place to germinate. Even if it does, it must compete with mature plants that tower above it and shade it from the critical energy of the sun. As a result, many grasses have evolved below-ground rhizomes that creep out in all directions. When conditions are promising, the rhizomes send up leaves and flowering stalks, laying claim to new territory.

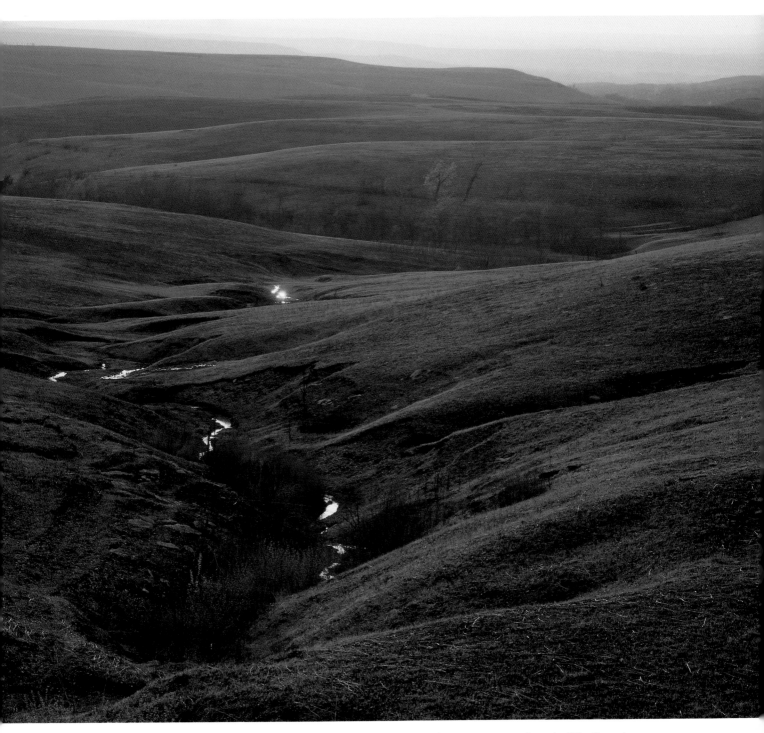

Within several days of the fire, grasses emerge from the sun-warmed soil to begin a new season of growth. (Riley County)

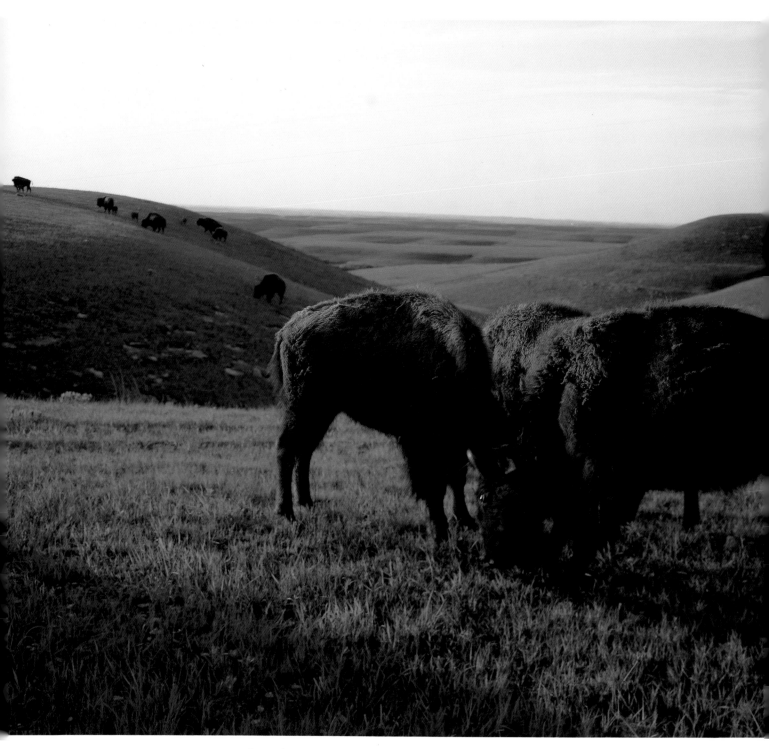

To bison, the newly sprouted grasses after a fire are a delicacy. (Riley County)

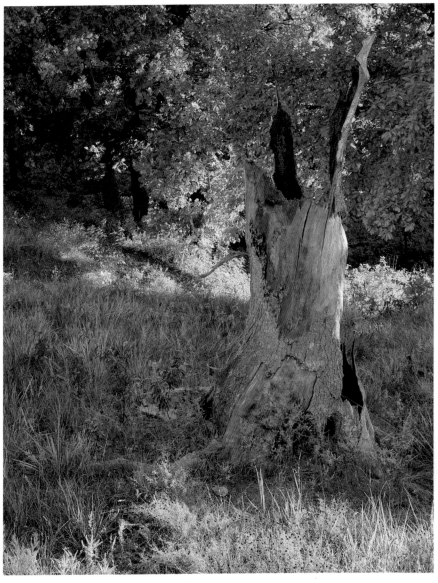

The very fires that allow grasses to prosper may eventually lead to the demise of forest giants such as this bur oak. (Riley County)

There are three main types of prairies in Kansas. Beginning in eastern Kansas and heading west, a traveler would first encounter tallgrass prairie; then, as the country grew drier the mixed-grass prairie would be crossed; and finally, in the arid western third of the state, the shortgrass prairie would dominate. If it were autumn, the awesome bronze beauty of the tallgrass prairie might inspire a "Wow!" If it were summer, the mixed-grass prairie might produce only a "hmmm" or a "ho hum," since it takes time and effort to appreciate its subtle complexity. If it were the middle of August, the shortgrass prairie could provoke an "Uh oh!" as the sparse vegetation and open ground signal a harsh environment with little water.

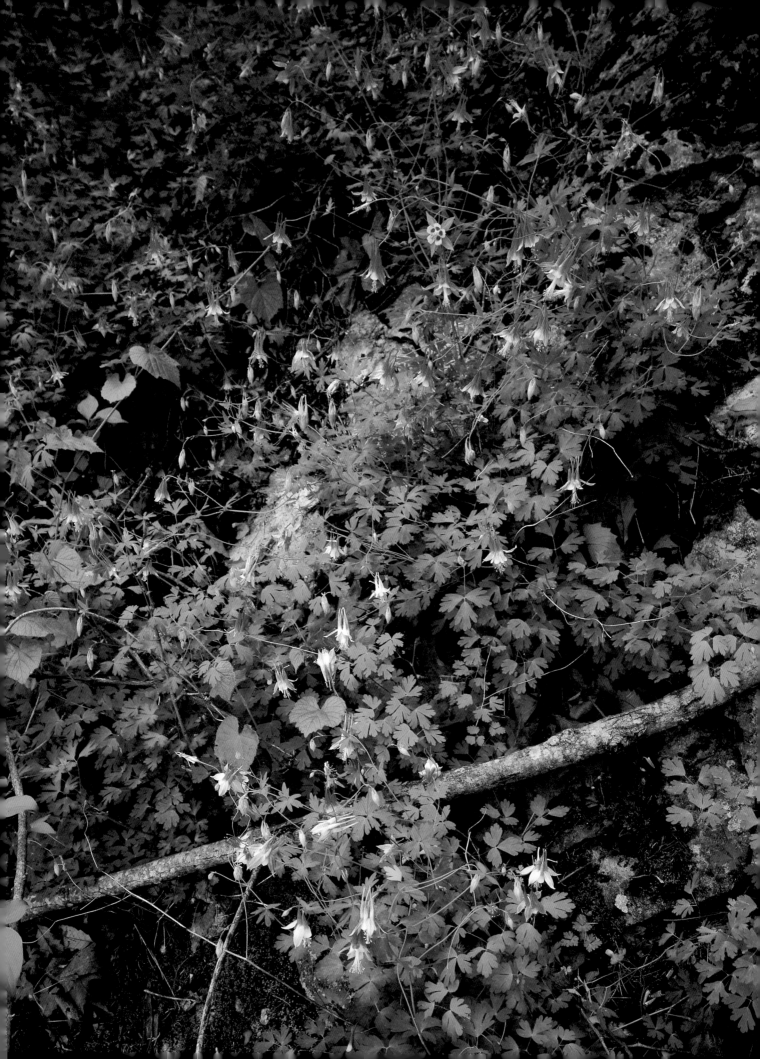

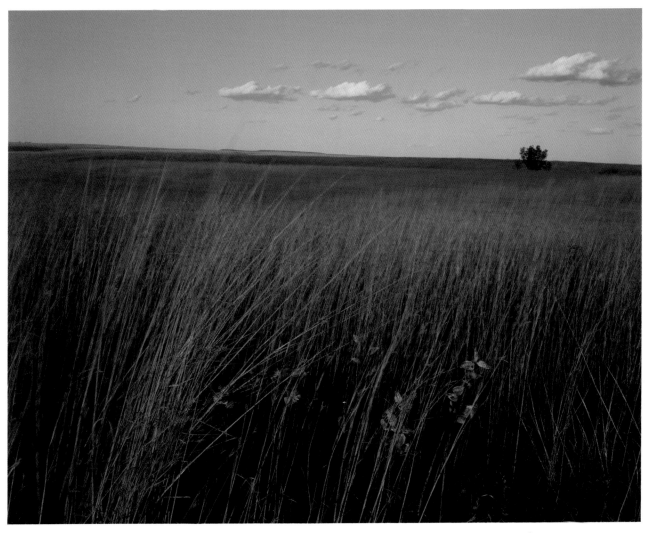

Big bluestem in its autumn hue, Konza Prairie (Riley County)

Facing page: Columbine in bloom, Elk City Lake State Park (Montgomery County)

For the casual observer, recognition of these three primary prairie types will suffice. Each is known for the growth form of its dominant grasses, although hundreds of other plants inhabit each kind of prairie, and each can be subdivided further, usually on the basis of a physiographic characteristic of a particular region. For example, the Kansas Natural Heritage Inventory recognizes five tallgrass prairie communities in Kansas. The northeastern tallgrass prairie is confined to the glaciated region of Kansas and grows (what little of it might be left) in deep, rich, wind-deposited (loess) soil. The southeastern tallgrass prairie occurs mainly in the Osage Cuestas. Similarly, the Flint Hills and Dakota or Smoky Hills tallgrass prairies are associated with those specific physiographic regions. The claypan prairie occurs in low, poorly drained soils in the southeast and south-central portions of the state.

The tallgrass prairie is tall because of one species of plant – big bluestem (*Andropogon*

gerardii) – a grass that is both big and blue. Early in the year it has a powder-blue tinge that is obvious only at close range, and for much of the growing season it seems too modest a plant to be the king of the tallgrass prairie. It sprouts from below ground in April and rapidly grows to knee height in the next several weeks. It dominates the tallgrass prairie for much of the summer, but in terms of biomass rather than height. Near the first of August, though, it begins to accept its responsibility and shoots its flowering stalk skyward with a speed that is almost visible. Before the beginning of September it will be 5 to 6 feet tall in most areas, and in extraordinary years it can reach over 10 feet tall.

Two hundred years ago the tallgrass prairie extended over 250 million square miles, covering virtually all of Iowa, most of Illinois, and much of a half dozen other states. Less than 2 percent of the native tallgrass prairie remains today, although the region is still dominated by tall members of the grass family, such as corn and wheat, and large grazers in the form of cattle rather than bison. The very conditions that supported the luxuriant tallgrass prairie, especially the sod or Black Gold, made it ideal for crop production. Kansas is fortunate to be at the center of the most significant strip of tallgrass prairie that remains – the Flint Hills – and to have within its borders other smaller prairie remnants in the Smoky Hills, Arkansas River Lowlands, Osage Cuestas, and Glaciated Region.

In addition to big bluestem, three species of grass typify the tallgrass prairie – little bluestem (*Andropogon scoparius*), Indian grass (*Sorghastrum nutans*), and in low, moist areas, switchgrass (*Panicum virgatum*). These species seldom grow side by side, nor are all four present in every reach of tallgrass prairie, but as a fraternity they define the tallgrass prairie.

This may seem like an overstatement, since over 600 species of plants occur in the Flint Hills, most of which are not even grasses. Significantly, approximately 150 prairie plant species reach the eastern or western edge of their distribution in the Flint Hills, which suggests that the Flint Hills are a good place for plants to try out traits developed elsewhere, a habitat receptive to immigrants with new adaptive skills.

From late April until the first frosts, the shag carpet of grass is penetrated by some of the most beautiful flowers on the continent. Large beardtongue and plains larkspur stand upright to attract attention from flying pollinators as well as the interested human observer. Species like butterfly milkweed shove aside neighbors and produce splotches of tomato-red flowers like random drops of paint on the canvas of the prairie. Many of the flowering plants are ephemeral, lasting only long enough to get the job of pollination done. Visiting the tallgrass prairie weekly is like seeing your nieces and nephews every six months – they have grown and changed in ways that make them almost unrecognizable.

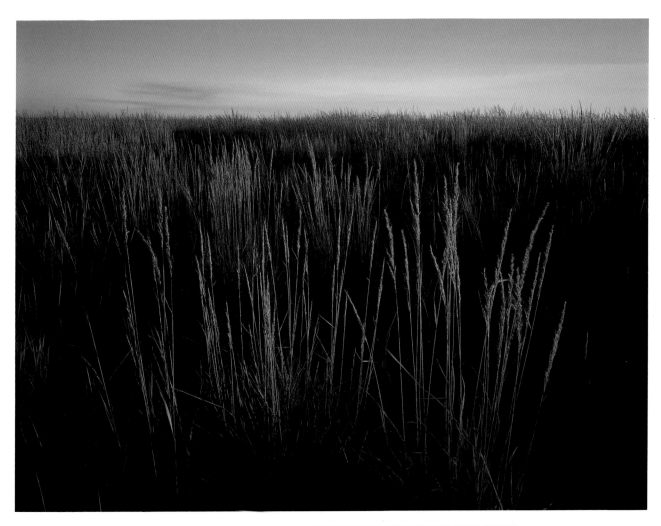

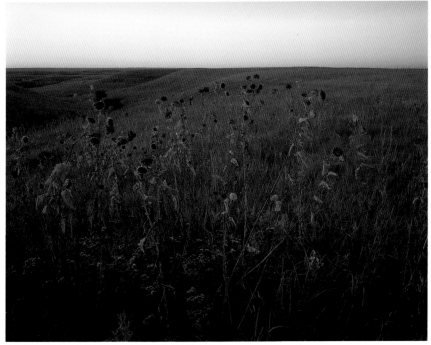

Indian grass on Konza Prairie (Riley County)

As autumn arrives, the prodigious production of the tallgrass prairie, including these seeds at the top of drying stalks of sunflowers, becomes available for harvest. (Riley County)

Though prairies are often thought of as treeless and even shrubless, there are both shrubs and trees that naturally represent the tallgrass prairie. Most of the tallgrass prairie receives enough moisture to support the demands of these plants, but fires occur often enough that most do not thrive. Low shrubs such as the sumac, wild rose, wild plum, and dogwood persist, as do elms and oaks along the less vulnerable watercourses through the prairie.

Relatively few true weeds or foreign immigrants invade a healthy tallgrass prairie. If the sod is intact and the native diversity of species is present, there is virtually no room for a nonnative to shoulder its way in. Specific human practices, however, make the tallgrass prairie vulnerable to invasion; plowing is the most obvious example. The replacement of native biodiversity with agricultural monoculture is complete, and the wounds are long lasting.

A more insidious practice – altering or preventing natural burning regimes – also produces serious effects, but these may not be as evident and thus not as lamented. Without fires every three to four years (the typical natural pattern), trees and shrubs invade and gain a foothold, eventually passing through the vulnerable sapling stage into maturity, when they are only rarely killed by prairie fires. Perhaps the most noxious of these nonalien invaders is red cedar (juniper), which readily takes over in the early stages of succession from unburned prairie to cluttered woodland. This process is occurring now throughout the tallgrass prairie, especially where human immigrants build new residences and imagine that evergreens will make their yards look like Colorado. But to the trained eye of a scientist or to a prairie aficionado, cedar forests are as jarring as fingernails on a blackboard.

The tallgrass prairie, rippling in every breeze, is commonly described as an inland sea because its vast, unadorned surface stretches to the horizon. More subtly, however, the tallgrass prairie is sea-like because of its undulating surface. The wind whips up waves on this sea of grass, much as it amplifies waves on oceans, and they move over the landscape at remarkable speeds. As the leaves of silicon-laden grass scrape over one another, they produce a zipper-like buzz – zzzzzzzzzzzzZZZZZZZZZZZZZzzzzzzzzzzz – as a wave approaches, passes, and departs. For an instant, that instant before complete recognition, the image is frightening: a large snake approaching at the speed of the wind and departing, uneventfully, just as quickly.

The mixed-grass prairies of Kansas, as the name implies, are populated by a mélange of grasses from all directions. Due in part to the midsize plants that grow there, and to its position in the middle of the state, the area is also called a midgrass prairie. Species characteristic of the moist tallgrass prairies spill over into the mixed-grass prairies, but occur

Facing page:
Locust tree in a
rocky refuge where
it is protected from
fire (Ottawa
County)

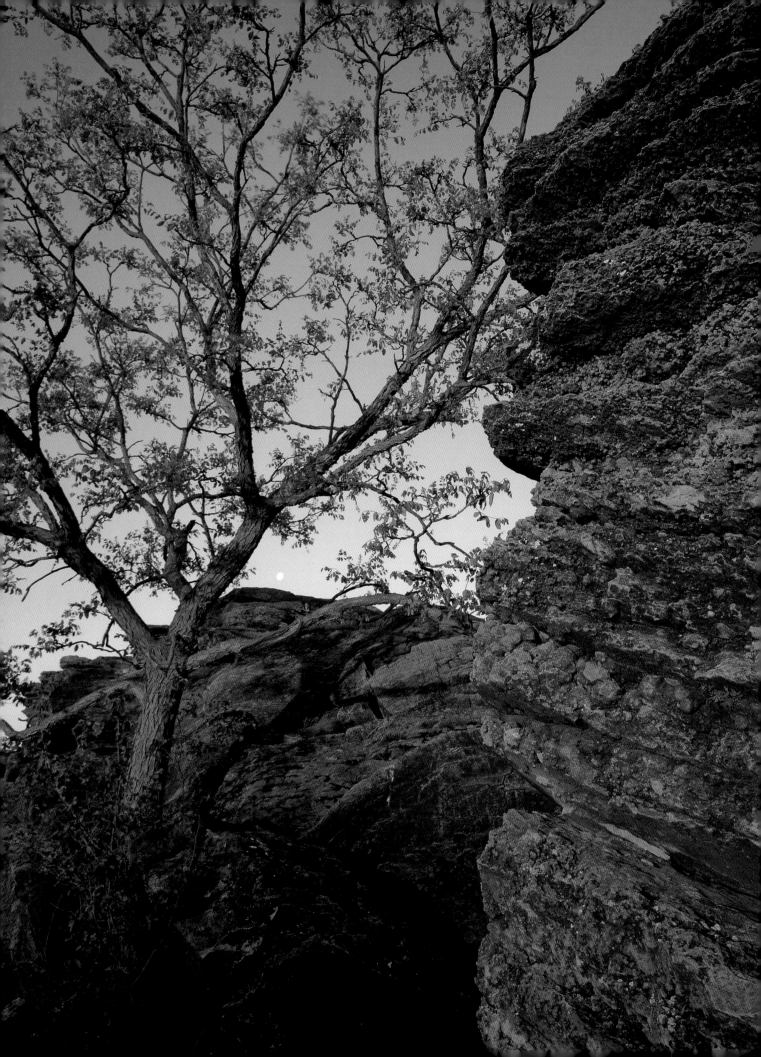

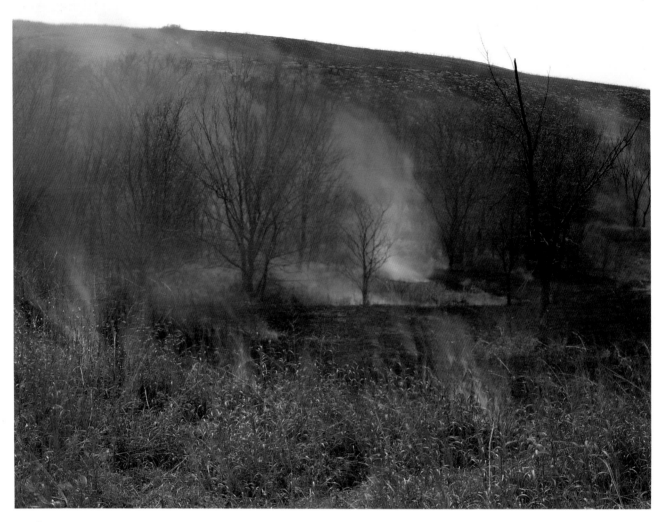

Fire burning into a wooded area of Konza Prairie. Fires like these will gradually injure or kill trees, leaving all but the wettest bottomlands vacant for pioneering prairie plants. (Riley County)

almost entirely in the lowlands where moisture accumulates. The western, drought-tolerant species converge on the dry ridge tops where most rainfall runs off or what does soak in is quickly sucked back out by dry winds.

The boundaries between the mixed-grass prairie and its neighbors to either side vary more than most. In dry periods, plants with their evolutionary roots in the arid west might emerge as dominate forms, pushing the apparent boundary of the mixed-grass prairie to the east. As the climate cycles back and moisture increases, these species might be overshadowed by eastern colonists, dragging the boundary west. It may take decades for these shifts to occur, though, because the blend of plants in this region includes representatives prepared to respond to any particular set of conditions.

Plants in the mixed-grass prairie tend to be shorter replicas of those to the east. Reduced moisture and nutrient levels are partly responsible for this phenomenon, stunting

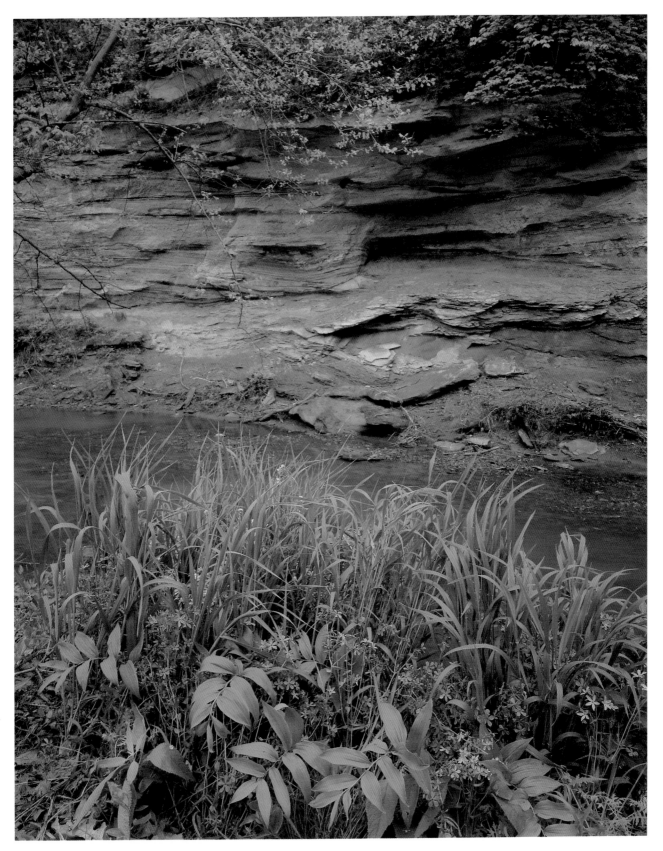

Blue phlox and Solomon's seal along Mission Creek (Wabaunsee County)

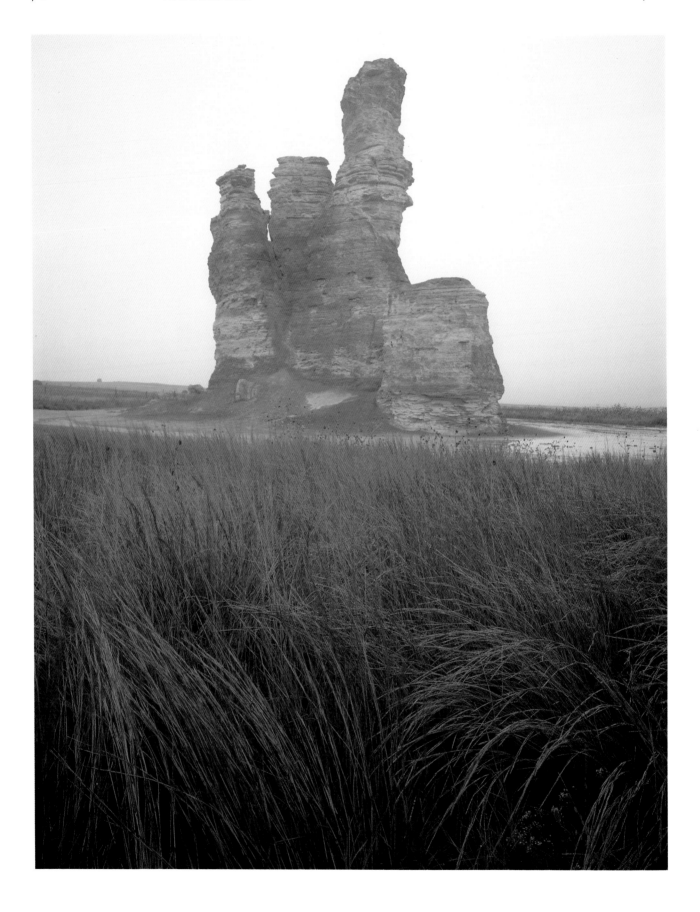

Virginia creeper and grasses in the Red Hills (Barber County)

Facing page: Mixed-grass prairie surrounding a fog-shrouded Castle Rock (Trego County)

individuals that would grow more robust under better conditions. But it is probably beneficial for residents of the mixed-grass prairie to remain somewhat shorter than their eastern cousins, because it leaves them less exposed to the cutting winds.

Within the mixed-grass prairie it is possible for visitors to witness the entire east-west gradient of conditions, and hence vegetation, over a relatively small area. Simply by walking from moist bottomland up the gentle slopes of a draw to the dry, exposed ridge tops, they can see how patches of big bluestem fade into the little bluestem and then change to shortgrasses, such as buffalo and sideoats grama, on the crests. But even within this short distance the margins between populations shift, depending on whether the slope faces north or south.

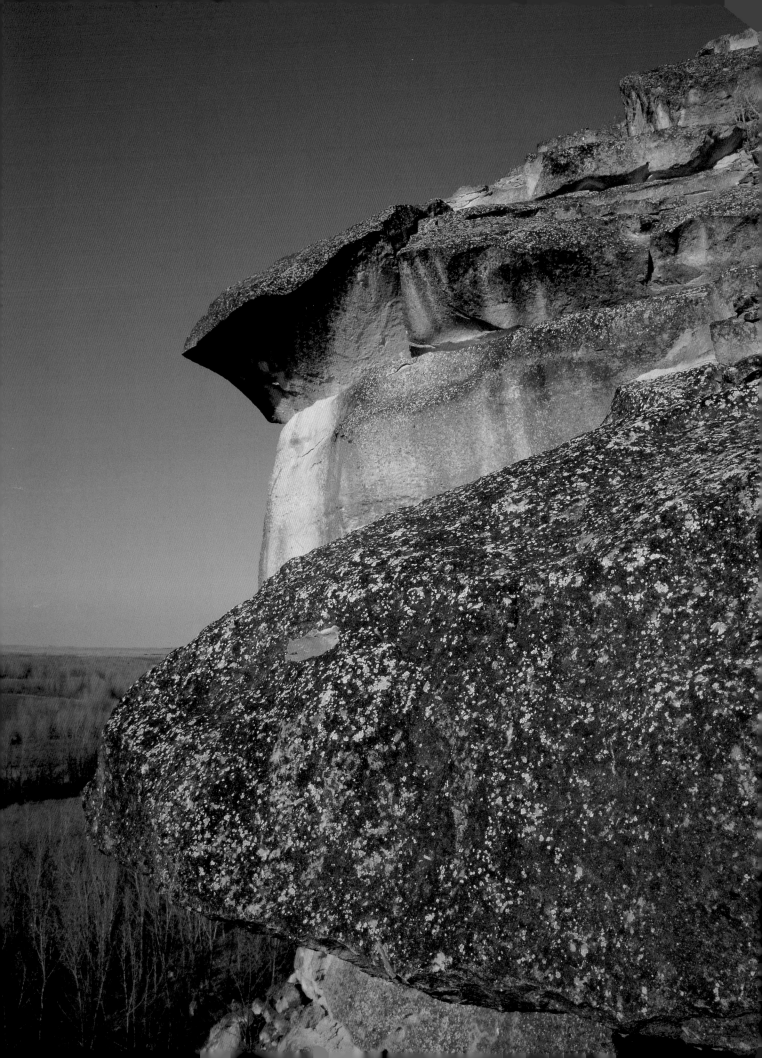

This is not to imply that grasses are the only vegetation in these prairies. Forbs – nonwoody, nongrasses – can form large patches of color when conditions are right. Delicate primroses dot the ground like scraps of thin tissue paper on cool moist mornings, and red and yellow Indian blanket flower grows in bouquet-like bunches. Trees are not abundant, but green ash, hackberry, and soapberry cluster near water sources.

Not only is the average temperature higher and the mean rainfall lower in the mixed-grass prairie than in the tallgrass prairie, but the extremes are more severe. Even in an average year the depth of summer is more stressful for plants, with rainfall unpredictable and the heat of the glaring sun a certainty. To hedge their bets, flowers that bloom all summer may become quiescent during late July and August before blooming again when conditions improve a bit in September. Uncertainty is the Achilles' heel of the natural world, and because the cost of failure to cope with climatic variability is death, the plants that survive exhibit traits that minimize risks as they wait out the bad times. This is a reasonable response to an uncertain future, but is not an option open to annual species – those that must germinate, flower, and set seed in one season. This factor alone promotes a community dominated by perennial forms that can lie low until conditions improve.

Running as a band down from the Smoky Hills across the Arkansas River (where specialized sand prairies persist) and into the Red Hills region, the mixed-grass prairie graces the landscape with a fine and varied mantle. It exudes variety, in both time and place, as the resident plants squeeze through a different environmental sieve each year. This land of flux has accepted many newcomers and, though it may not host them all with equal hospitality, it does provide space for pioneers to take a chance.

In the western quarter of the state, and mostly above 3 thousand feet in altitude, are the shortgrass prairies of Kansas. This area lies in the rainshadow of the Rockies and is too far west to benefit often from moist air flowing north from the Gulf of Mexico. This circumstance tends to give the shortgrass prairies a tough feeling – tallgrass and mixed-grass prairies can be hot, thorny, and buggy – but in the shortgrass prairie there is always the sense of impending demise. The land looks rugged and tense, compared with the prairies to the east.

The High Plains are composed of sand, silt, and gravel carved from the Rockies by wind and water. Persistent prevailing winds from the northwest have deposited great layers of sediment on the east-sloping face of the High Plains, and ancient rivers carried sediment loads that sorted into gravel, sand, and silt deposits as the grade eased and the water slowed. But the job is not complete. The rivers of the west continue this tradition whenever they flood, bearing huge deposits into Kansas each year.

Facing page: Bold ledges in Cedar Bluffs State Park (Trego County)

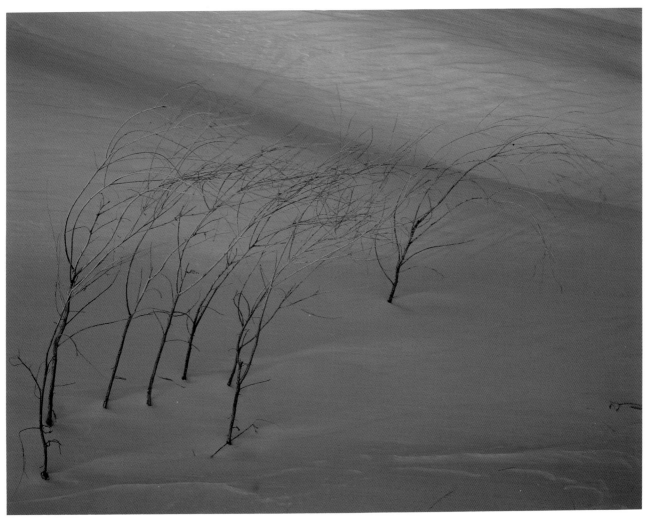

The plants of the shortgrass prairies are shorter than those of the eastern prairies and less varied. Grasses still dominate, especially blue grama and buffalo grass, and many of the common grass species from the tallgrass and mixed-grass prairies can be found here in pockets of suitable habitat. Sand bluestem frequents low, moist areas along with little bluestem, blue grama, and dropseed. But here a fifth of the plants are grasses. The remaining species, the wildflowers or broadleaf herbs, are fewer in number than in prairies to the east. However, because the ground is more open here than in the eastern prairies, their blooms are more conspicuous. Tan earth becomes speckled with color when scarlet globemallows open pink-orange flowers, when white evening primroses and beard-tongues blossom, and vetch and prairie clover are transformed into pastel carpets. Shrubs and trees are even rarer here than in the mixed-grass prairies, but saltbush, rabbitbrush, sandsage, and broom snakeweed grow where moisture is plentiful.

The two western corners of the shortgrass prairie in Kansas are influenced by floras from different regions. In the northwest, plants associated with the upper Great Plains spill into Kansas. In the southwest, plants more characteristic of the arid deserts filter in, including all nine types of cacti found in Kansas, five of which occur only in this habitat. Along with yuccas, cacti create the impression of country farther west than the map indicates and argue that the desert is not far away.

In the very southwest corner of Kansas lies a haunting, windswept expanse of shortgrass prairie, the Cimarron National Grassland. Here the wind is a perpetual companion, and the bunch grasses move independently in the gusts, unlike the synchronized waves of the shoulder-to-shoulder grasses farther east. The wind whistles, literally, and particles of sand blow over the surface, blurring the substrate. This striking region, managed by the U.S. Forest Department, was acquired by the federal government in the 1930s to prevent soil erosion in a region especially hard hit by the droughts of the period.

Within the shortgrass prairie two variants grow out of the distinctive sand and gravel bottomlands of the Arkansas and Cimarron Rivers. The sand prairie and sandsage prairie lie south of these rivers where wind and water have heaped sands brought in from the west into modest sand dunes – averaging 20 to 40 feet in height but reaching 80 feet in some places. Plant communities have taken root atop these dunes and helped stabilize them. The microhabitats on the dunes are subject to rapid alteration, so these prairies host a larger percentage of annual plants than the other prairies. Annuals, though vulnerable to year-to-year vagaries of the environment, are also equipped to store resources quickly, should a good year be in the making.

The shortgrass prairie is knee-deep at best and flutters rather than waves. Not much sticks up from the close-cropped fringe, and everything that does becomes a perch for birds. There is a lot of space between plants in this harsh environment, space that would be occupied by vegetation in the moist prairies to the east. Yet unlike the tallgrass prairie, where thorns, chiggers, and poison ivy lurk unseen, the shortgrass prairie is open about its rules for survival, which are as difficult as they are obvious.

FORESTS AND WOODLANDS

In the eastern quarter of Kansas, the vast prairies of the Great Plains collide with the immense eastern deciduous forests. Like waves beating against a cliff, the tallgrass prairie laps at the oaks and hickories along an irregular but obvious boundary.

The deciduous forests of North America were immense, stretching from the eastern

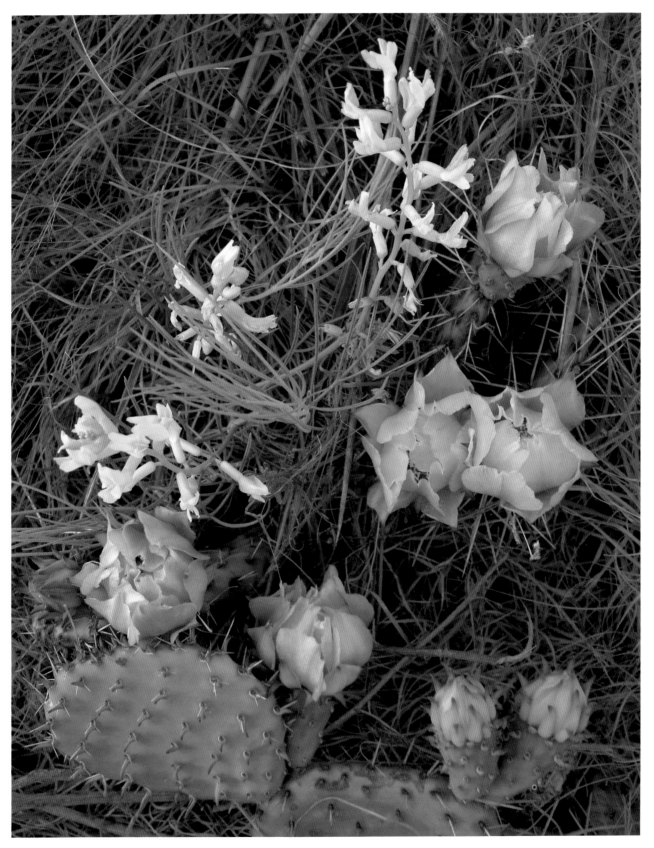

Prickly pear in bloom in the shortgrass prairie of western Kansas (Gove County)

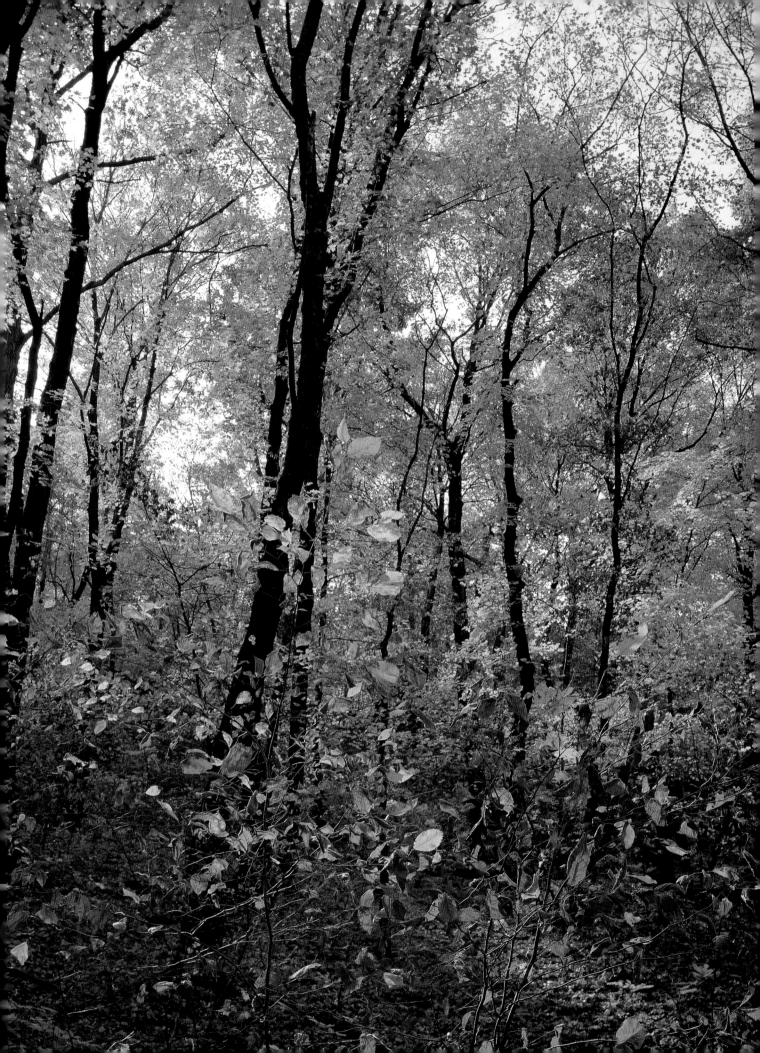

Elderberry in bloom in a wooded area of western Kansas (Scott County)

Facing page: Forests and woodlands make up a small portion of the natural landscapes of Kansas, but add beauty beyond their abundance. (Linn County)

seaboard into eastern Kansas. Even at their western terminus they are dense and composed of hardy survivors that live hundreds of years. It is difficult to know where the forest prevailed prior to settlement by Europeans, but estimates suggest that less than a third of an original 4.5 million acres persists, and almost none of that is virgin forest. Since forests provide innumerable resources, from building materials to combustible energy, they remain only where access is difficult, or where they have been protected, replanted, or have regrown on their own.

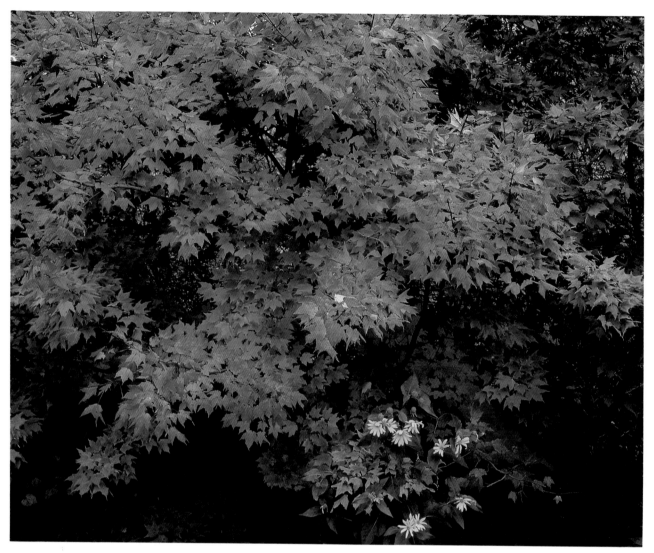

*Rich autumn colors
of maples with a touch
of yellow sunflowers
(Crawford County)*

*Facing page:
Deep hardwood forest
along the eastern edge
of Kansas. These forests
consist of layers of
vegetation, including a
canopy, an understory,
and ground cover.
(Linn County)*

In settlements around the world, humans use trees to claim space. In grasslands, we add trees as windbreaks along fence rows to distinguish one property from another; sometimes we view trees as a resource, but more often we plant these imitation forests for sanctuary and seclusion. In forests, we clear trees to make space for dwellings and agriculture, but we usually leave a fringe of trees to make the statement that this is human habitation, and it is "mine." Wherever forests are cleared for agriculture or development, however, there is a sense of disruption. Even manicuring the edges of a cleared area cannot alleviate the feeling that injury has somehow been done to the landscape.

Kansas contains both forests and woodlands, but the distinction is a fine one. Forests tend to be well structured, with several identifiable layers. In temperate regions there are

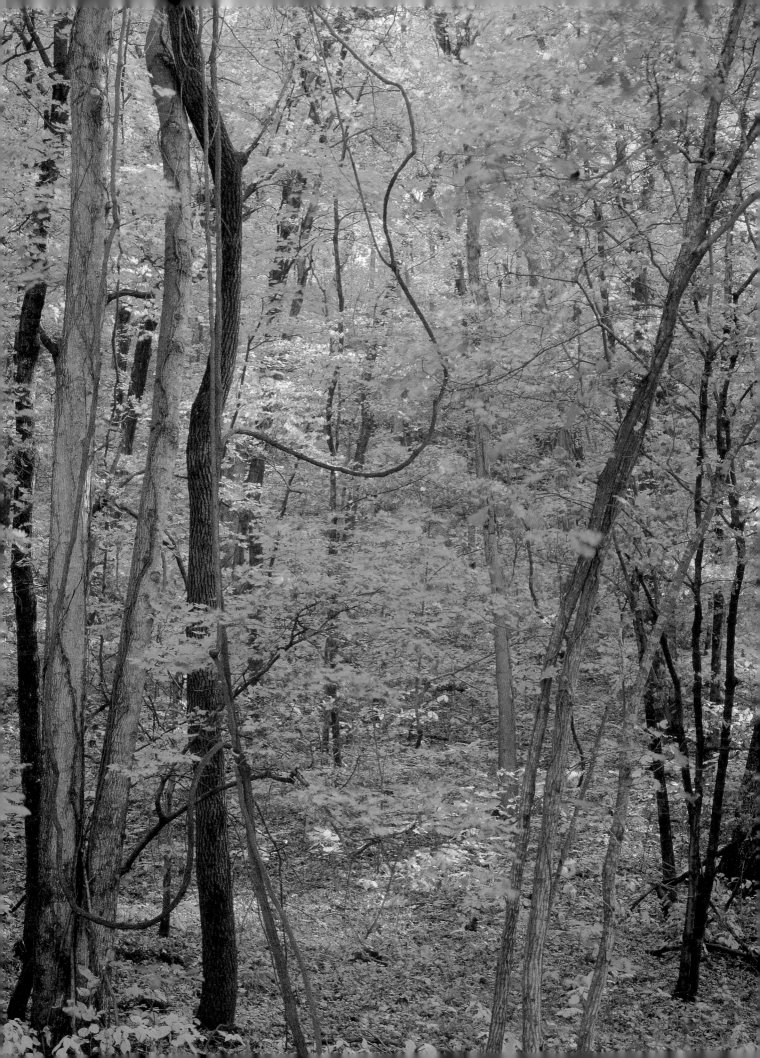

*May apples in the deep
shade of an east Kansas
woodland (Douglas
County)*

usually three layers (and up to five in tropical forests), including a low herbaceous layer,
an understory of small trees and shrubs, and a canopy layer composed of the tops of the
dominant trees. Woodlands are often more open, and their "layers" are intermingled in a
way that defies categorization.

By far the most important structural feature of a forest is its canopy. This layer, only a
dozen feet thick on average, intercepts sunlight so effectively that the understory is left in

Seasonal indicators within the forest: pink redbuds, the earliest flowers of spring (Riley County), and white ash leaves signaling autumn in Schermerhorn City Park (Cherokee County)

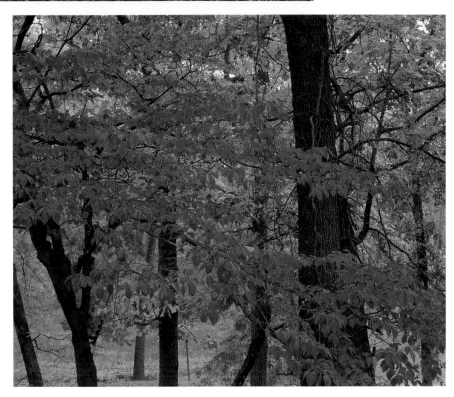

perpetual dusk. This characteristic of the dominant trees, coupled with their water-guzzling roots, make life on the forest floor a tough competition.

To get around these difficulties, the plants that share the forest with trees have evolved clever schemes to capture resources and outwit the trees. Some plants have learned to tolerate shade, living off the crumbs of light that manage to filter between the tree leaves. These light-scavengers are slow growing and unimpressive, except in their tenacity. Other plants and understory trees rely on timing, taking advantage of the deciduous habit of the large trees. The forest understory can be brilliant in the early spring when these plants mobilize their resources for a quick foray into the sunlight before the tall trees leaf out. Some, such as redbuds, flower early, even before they set leaves, using their showy flowers to attract the early pollinators before the forest becomes cluttered with competitors.

In Kansas, the true forests are distributed along the eastern border where enough rainfall accumulates to satisfy the thirsty oaks and hickories and, in the drier reaches, hackberries and an occasional walnut. The most imposing forests grow in the Ozark Plateau in the southeast corner of the state, where the forest is deep, dark, and primeval. In most other places, forests are slow growing and sluggish in reclaiming disturbed land. But on the Ozark Plateau the forest seems aggressive. It doesn't hang back, waiting until it is unchallenged to reclaim land. Instead, its seedlings and saplings, along with the tendrils of fast-growing vines, lead the charge back over disrupted landscapes, in time frames that are short compared with the growth of most forests.

The Ozark Plateau upland forests are perpetually damp from both the high rainfall and a land surface that oozes water. The fractured, weathered limestone underlying the plateau accepts and discharges water with ease, providing habitats that are among the most distinctive in the state, especially for creatures that require a reliable water source. These forests are the center of the most diverse amphibian communities in Kansas, including a dazzling array of salamanders. Several species are indigenous to the clear creeks of Cherokee County, including the greybelly and grotto salamanders as well as the endangered cave salamanders.

The deep forests are presided over by several regal tree species, including white and black oaks, Shumard's oak, and butternut and shagbark hickories. The understory contains spicebush, sassafras, and dogwood, which produces abundant blossoms in the spring. Beneath this layer grow a variety of smaller plants and a spongy carpet of mosses.

North of the Ozark Plateau and extending along the Missouri River are the extraordinary eastern upland forests, which inhabit the upper slopes of the Glaciated Region and

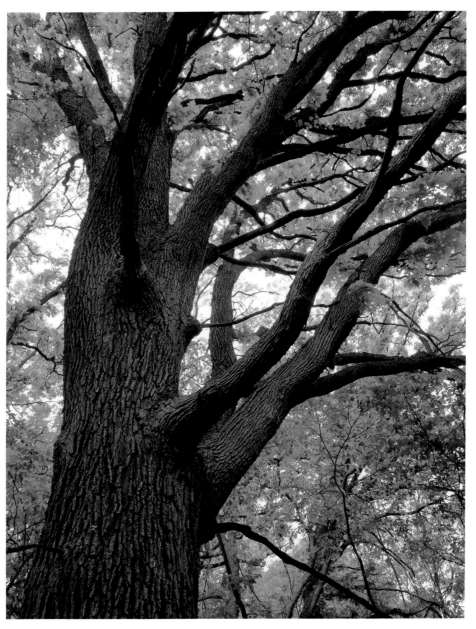

Stately bur oak in Breidenthal Reserve, one of the patriarchs of Kansas forests (Douglas County)

the Osage Cuestas. Red and black oaks dominate, along with several species of hickory and American elm. On the bluffs above the Missouri River, maple and basswood trees assert a strong presence. The forest thins as it stretches west, extending finger-like projections into the adjacent prairies, and it is along these habitat corridors that forest dwellers try out prairie living. Even though the eastern deciduous forest reaches its margins in Kansas, the forest here is, at its most dense, a classic one, vertically stratified.

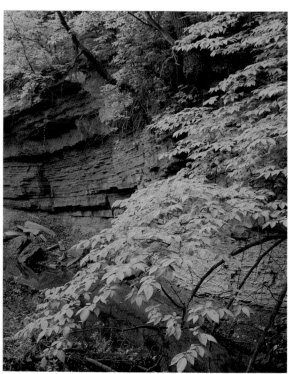

Taking refuge where offered, blue phlox nestles in the crotch of an American elm. (Wabaunsee County)

The sandstone at a bend in the river, covered by a green shawl of leaves (Douglas County)

A striking band of forest pops up in the modest Chautauqua Hills of southeast Kansas. The forest, composed primarily of the sand-loving blackjack and post oak, rises out the landscape so suddenly, and in so distinctive a manner, that a traveler is instantly aware of having entered a new biotic zone. These forests – more accurately, woodlands – include gentle sandstone slopes of regal oaks surrounded by natural prairie lawns. This area has received much "management" – from altering the natural fire regime to opening the forests for grazing – but the few natural patches that remain are breathtaking in their simple elegance.

Nestled amid the forests are glades, hardy patches of prairie that persist in microhabitats unsuited for trees. These isolated, often tiny enclaves are the result of past geologic processes that have retarded normal soil development. They may seem to be filled with grassland refugees – Indian grass, switchgrass, and big bluestem – but their barren nature reveals their true origins. Because of their thin soil and open aspect, these patches actually

Poison ivy, creeping up the face of a sandstone wall in Breidenthal Reserve (Douglas County)

host their own distinctive flora – plants with exotic names such as heliotrope, wedgeleaf, adder's-tongue, and showy stonecrop – while effectively excluding plants more typical of the surrounding forest.

Our current idea of forests was shaped by nineteenth-century artists, who portrayed the ideal forest as manicured and managed to our liking. We still like to imagine forests as enchanting habitats filled with pleasant, or at least benign, inhabitants. We are not entirely wrong, since many places in a natural forest are idyllic. But the forest is composed of many long-lived species of plants that must endure the assaults of hundreds of generations of consumers. In the course of two centuries of life, an individual tree may encounter thousands of species of insects, all attempting to lay claim to it as food or as a place to live. Deer, elk, and other herbivores browse on the trees, defoliating them year after year.

Staying alive for centuries is a tough business; to counter these depredations, trees and woody perennials have evolved effective defenses. Oaks contain chemicals (primarily tannins) that inhibit digestion, making oak leaves a poor choice for many animals. Physical defenses such as thorns, or tough fruits such as acorns, also abound. Some plants are toxic, including poison ivy (a large woody vine in its most pernicious form), which produces large, weeping blisters on those most susceptible.

Wind is part of what a prairie is, but forests often block the movement of air and generate a stillness that can be eerie rather than calming. In humid forests, especially in the Ozark Plateau or along the watercourses of the Wellington-McPherson Lowlands, a visitor finds breathing difficult in air saturated with moisture. But the moist, motionless air sustains sweet scents from blooming flowers as well as the fetid scents of decay. On a placid morning in the dead of summer, these mists and odors can overwhelm the senses and give the deep forests a haunting charm.

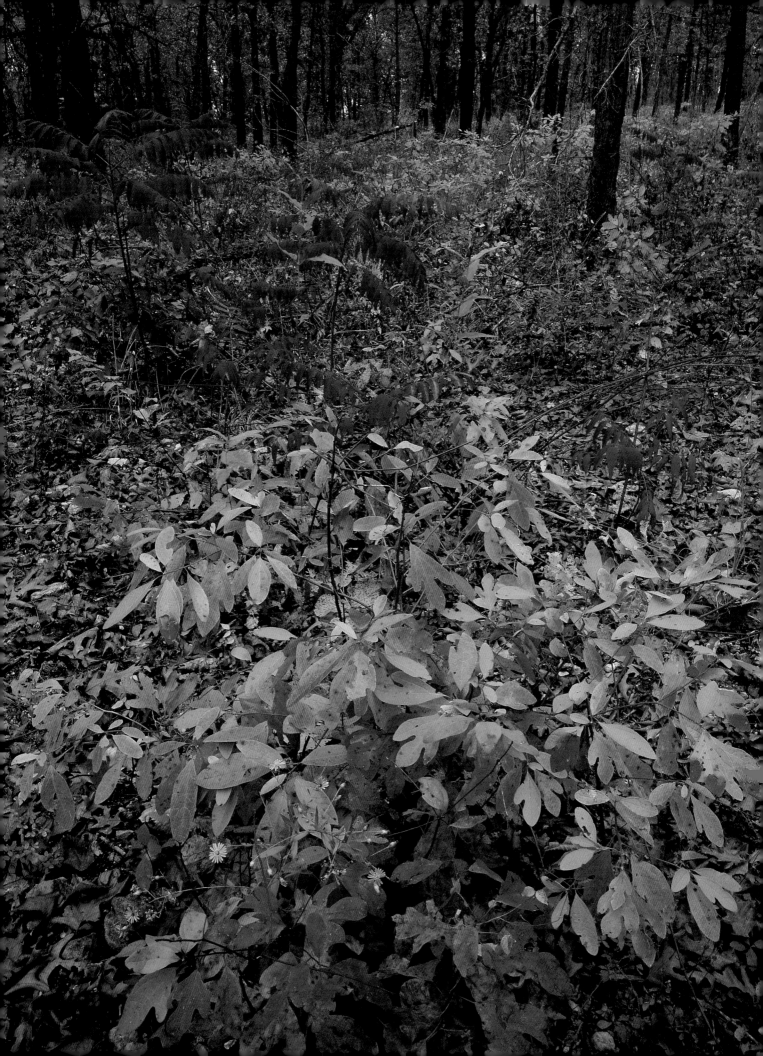

Fall reveals itself when the green pigments of chlorophyll are withdrawn from the leaves of forest trees. (Wilson, Marshall, and Cherokee Counties)

WATER AND WETLANDS

Water is essential because it sustains life. It is made precious by its scarcity. Every living organism requires at least some water and most require enormous amounts throughout their lives. Though water is everywhere, in the atmosphere and in the driest ground, access to it can be problematic. Because most organisms are 90 percent water, they tend to lose moisture to the relatively dry outside environment. Thus, places with plenty of water are true oases and become focal points for biological activity.

Only a tiny fraction of Kansas holds surface water for even a part of the year, and little of that persists year-round. Perhaps one percent of the state's surface is covered with water

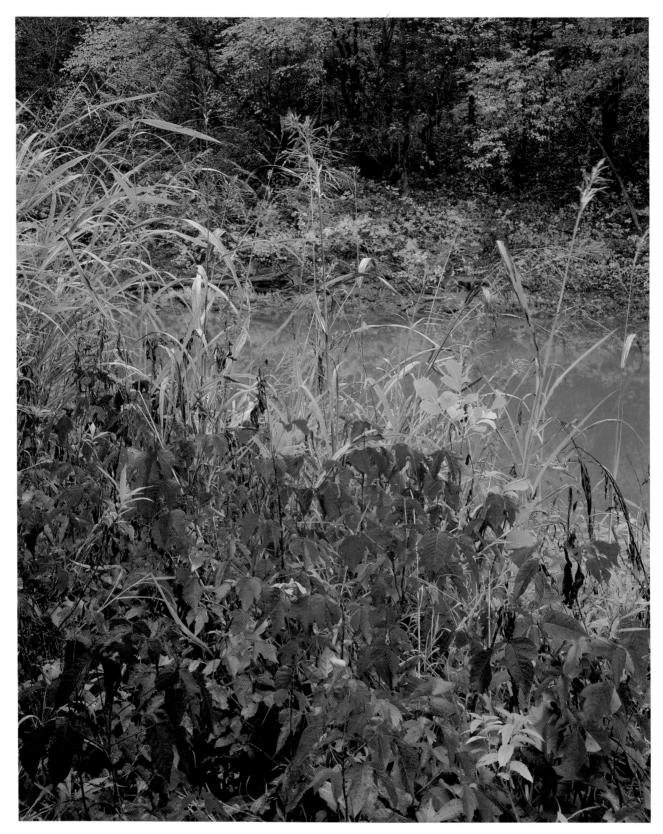

Grasses retain their green hues, while early fall brings out the reds of poison ivy and faint hints of yellow in the surrounding forest. (Wabaunsee County)

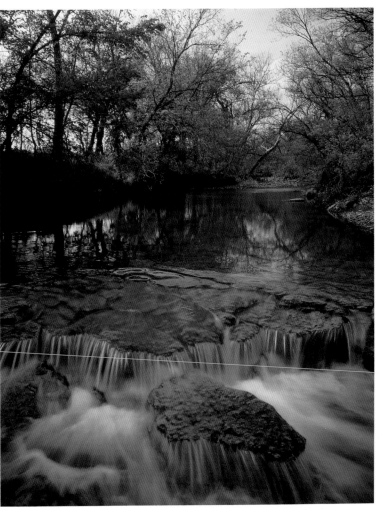

*Cascading water
over sharp edges of
limestone along Mill
Creek (Wabaunsee
County)*

throughout the year, and much of this, in the form of reservoirs, is of recent origin. These dams, constructed at great expense to provide drinking water and recreation or to control floods, reveal just how important water is to humans.

The transition from the terrestrial habitats – prairies and forests in Kansas – to the aquatic might seem the most abrupt imaginable. One habitat is dry and often dusty, the other cool and moist. But even here the segue is gradual. It's not hard to distinguish forest from water, but in between, the ground ranges from dry to moist to saturated. This transition zone may be quite narrow, as along the edge of a small pond or an intermittent stream, or hundreds of yards wide, as along the broad floodplain of major rivers and streams.

In even the narrowest of these zones, characteristic communities develop, often composed of water-loving plants. Though saturated soils do provide abundant water, they

Small, persistent pools of water can be oases when water is scarce. (Douglas County)

Facing page: The transition between water and land is complicated by both plants that emerge from the water's edge and water that seeps into the adjacent soil, as along the South Fork of the Cottonwood River in the Flint Hills Tallgrass Prairie Preserve. (Greenwood County)

also become impervious to the movement of gases, particularly oxygen, that promote dynamic biological interactions below the surface. But certain water-loving specialists, such as sedges, have diversified in these habitats, and algae can form a green scum over the brown soil. In the water itself, cattails, reeds, and watercress flourish.

Floodplains – those areas where the river has flowed, or flows only during a flood – provide fertile but unpredictable habitats. Just as surely as the river once flowed there, it will again, and plants that take advantage of its productive soil must cope with its transitory nature. Nevertheless, these habitats support a distinctive and dynamic plant community.

All large rivers that flow slowly over relatively flat ground generate floodplains. As it meanders gradually downhill, the current pushes hardest at the entry to each bend, slowly

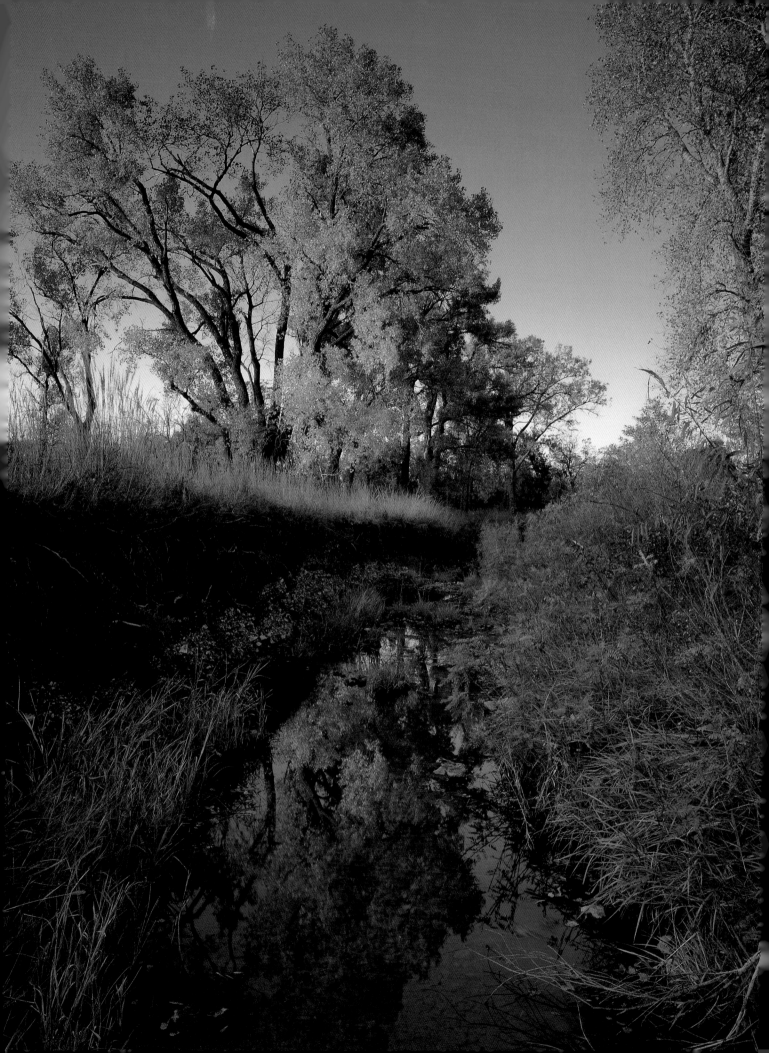

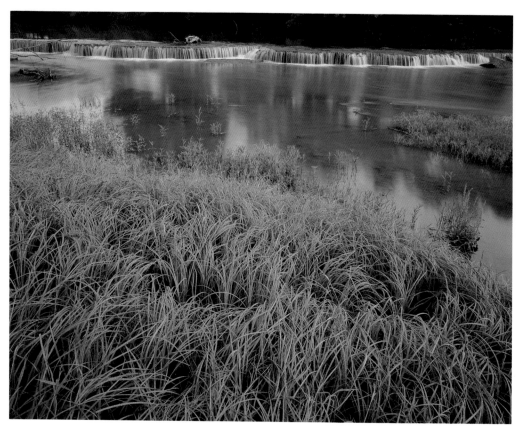

Sedges, a perfect example of the typical riverside plant, below Osro Falls on the Big Caney River (Chautauqua County)

eroding away that bank and eventually cutting its way downstream. Water flows more slowly on the inside of the bend, so some of the sediment load is dropped there, forming sandbars. The result of this meandering, cutting, and depositing is that over the course of decades to centuries, a river or stream squirms back and forth across the breadth of the valley which is cut by the water flow.

The plant community in floodplains is usually composed of an understory of mixed grasses and herbaceous plants and an overstory of trees. The understory plants of a recently flooded area may be "weedy" species – those that can quickly mobilize the available resources in new real estate. Through time, though, the community will stabilize, as deep-rooted perennials begin to dominate the floodplain. Dozens of species of sedges and rushes may occur in any one site alongside prairie cordgrass and eastern gammagrass. Fast-growing trees like cottonwoods also move in quickly to stake a claim, and sycamores, hackberries, and box elders eventually join them. Toward the edges of the floodplain, where the soil is well drained and drier, elm, ash, and maple trees flourish, eventually producing a mature community with trees over a hundred feet high. The dense gallery forest

becomes home to squirrels, and the forest edges are ideal for deer. Floodplains in the east, such as those associated with the Missouri River, are moister and more luxuriant, and in the days before flood "control" may have stretched a mile or more on either side of the river. In the west, the floodplains of the Republican and Arkansas are not quite as broad and, as a result, do not support as diverse a plant community. Their soils are sandier and more porous, making life more tenuous.

These ribbons of habitat are significant in their own right, because they yield distinctive communities that tolerate the dynamic conditions of the floodplains. But they also take on an important role as corridors for the movement of plants and animals. In Kansas these fingers of habitat stretch hundreds of miles and link thousands of watersheds and scores of drainages, providing passage through otherwise inhospitable terrain.

Floodplains may be an inviting habitat, but it is the water itself that is irresistible. Water literally signals its importance as it sparkles and glistens its way into our senses. It is tempting to imagine that creatures respond, like humans, with a sigh of relief when they hear water trickling and gurgling from springs and streams or lapping at the edges of pools and lakes. It is no surprise that water is the focal point of so much activity in the natural world.

Deep sandy banks, deposited by the earlier meandering movement of the Chikaskia River, are eroded by more recent flows. (Sumner County)

Normally sedate streams and rivers can go on rampages, rising rapidly and, when they recede, leaving debris high in the trees. (Wabaunsee County)

We generally think of water occurring naturally in rivers and lakes. But only a few major rivers traverse Kansas, and all of them have been significantly altered by human intervention. Natural lakes are even rarer, perhaps numbering fewer than a dozen, and most of those are found at the bottom of old sinkholes that have become sealed by clay. Of course, thousands of ponds, lakes, and reservoirs have been constructed in the last 50 years. Opportunistic cottonwoods and red cedars quickly populate their shores, and with pond turtles sunning on their rocks, it's easy to mistake them for natural wonders. However, the bathtub rings of washed shores around reservoirs and persistent snags from the trees killed when the land was flooded advertise their unnatural origin.

In the hydrologic sense, Kansas oozes rather than flows. Thousands of springs and seeps dot the landscape, producing cups to bucketsful of water each day. These might coalesce into rivulets and then to streams and rivers, or simply produce local hot spots of moisture-dependent activity. Some seeps can be spotted by their slightly darker shade of vegetation; others may remain hidden until they reveal themselves as squishiness underfoot. If seeps or springs occur in low basins, the water may accumulate in pools or in larger marshes and swamps.

Blue mustards and cottonwoods along a broad floodplain (Thomas County)

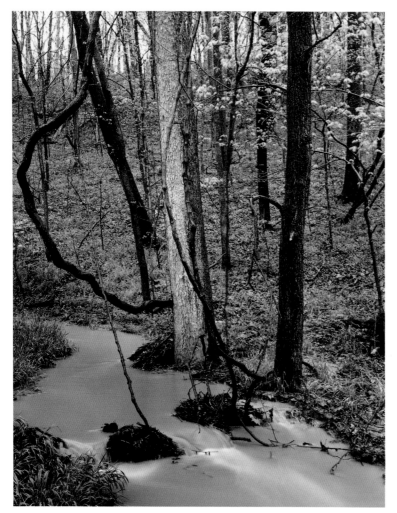

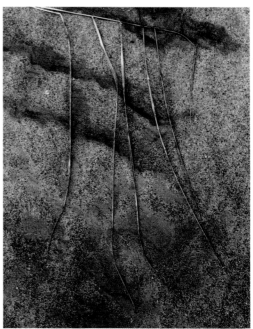

Flash flood along the Missouri River bottom-land (Leavenworth County)

Grass stems on washed sand left behind by flood-waters (White Woman · Creek, Wichita County)

Individual seeps are the source of relatively little water and produce almost no surface runoff. They are simply important bits of moist habitat embedded in the surrounding matrix of prairie and forest. In eastern Kansas water percolates down through cracks or lines of dissolution in rocks underlying the surface, until it encounters a relatively impervious layer. At this juncture it will collect, eventually squeezing out laterally to an edge or a bank where it emerges on the surface as a seep. The Flint Hills are renowned for their perched water tables, so called because of the bands of moisture and telltale vegetation associated with the interfaces between limestone and shale.

Western Kansas is underlain by the massive Ogallala aquifer, a sand and gravel sponge that holds a large proportion of the Great Plains' water. The Ogallala, which extends well beyond the borders of Kansas, was formed by the massive degradation of the Rocky

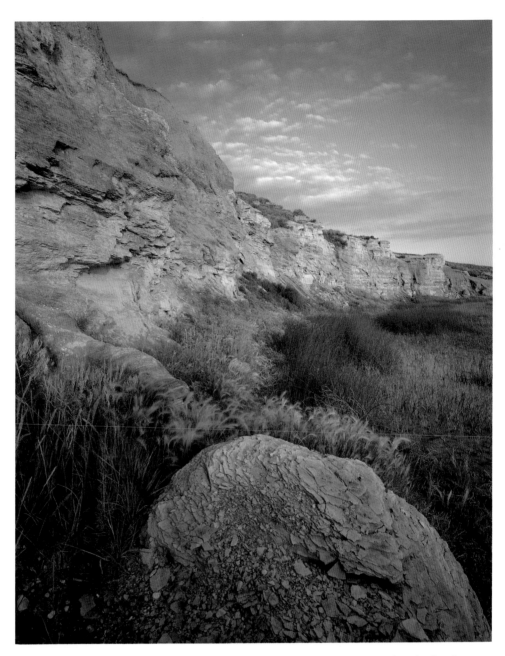

*Rich wetland at the
bottom of a sandstone
bluff (Gove County)*

Mountains. Sand, gravel, and clay accumulated over millions of years and has become
the matrix; its interstices hold an ancient underground lake. The major rivers of western
Kansas, their primary tributaries, and many of their little side cuts and draws have
eroded down into the Ogallala, which then seeps water as though it were wounded.

The Ogallala aquifer has served humans well over the last century, but continual
drawdown has left its resources depleted. The water table has dropped, and many creeks

Wetlands become focal points for plant diversity, which in turn engenders a rich fauna. (Barber County)

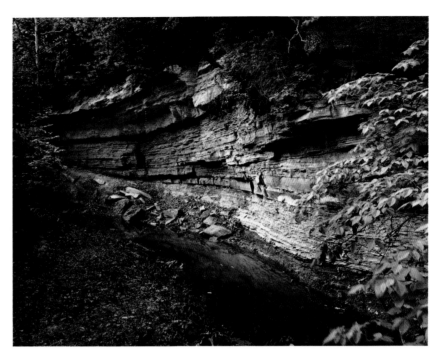

*Multilayered ledge
of Ireland Sandstone
in Breidenthal Reserve
(Douglas County)*

and streams that relied on a seemingly unlimited supply of water now originate above the amended level of the groundwater, significantly reducing the downstream flows.

The distinction between a seep and a spring is a minor one, related to the accumulation of surface runoff. Either may be perennial or intermittent, depending on whether it flows continually or responds to threshold levels of rainfall. Because of their benign conditions and isolated location, perennial springs often host a distinctive community of plants and animals, including unique species. Intermittent water sources challenge the survival skills of the organisms that use them, and many have evolved the remarkable ability to retire to a drought-resistant stage until the flow is resurrected. Microbes form resistant cysts, and many invertebrates go dormant, curtailing their metabolic processes to conserve resources. Even large animals like crayfish and frogs can bury themselves deep in the mud for protection until the aquatic habitat is recharged. Many of the largest springs are in the Flint Hills, and one, Rock Spring in Dickinson County, produced about a thousand gallons per minute in the 1950s. But like the seeps in the west, its flow has declined as the sustaining water table dropped.

Across the southern third of Kansas a variety of sinks and basins serve as seasonal wetlands. These depressions are usually formed when underlying rocks dissolve and cause the surface to collapse. Gypsum and salt beds are particularly susceptible to this process, but

limestone and sandstone also spawn basins. Even though these structures are often formed by underground water flows eroding or dissolving their foundation, they usually end up with no internal flows once the surface collapses and the basin is formed.

Instead, these natural bowls receive most of their water from rain and snow, so they are wet only seasonally. After spring showers or summer thunderstorms, highly localized run-off flows into the basin, carrying with it the material to seal the bottom. Water may remain in these shallow pools for days or weeks. The Kansas Natural Heritage Inventory estimates that these seemingly insignificant habitats host over 60 percent of the rare aquatic plant species in Kansas; 10 percent occur only in these temporary pools.

In a few particularly large depressions or renegade oxbows, enough water may accumulate to persist throughout most years. Here relatively permanent aquatic associations may develop, producing the uncommon swamps and marshes of Kansas. These wetland soils are invariably saturated, and large amounts of organic material accumulate in the fetid soup. The few true swamps in Kansas are associated with the large rivers in the east where backwaters and oxbow lakes have formed. They are dominated by woody perennial shrubs and trees such as blackwillow and buttonbush.

More common than swamps are marshes, low wetlands dominated by herbaceous plants. Typical wetland plants ring their edges, each species establishing itself in the depth of the water it prefers. Again, sedges and rushes rule, although cattails are the most obvious and perhaps characteristic plant of the wetlands.

Two of the most impressive marshes in the Great Plains – Cheyenne Bottoms, a freshwater marsh, and Quivira, a salt marsh – lie within Kansas. Situated in the center of the continent, the area that was to become Cheyenne Bottoms has risen and sunk, has been inundated with seas from the northwest and southeast, and has been covered with surface deposits from both the Rocky Mountains and the Canadian glaciers. Approximately 5 million years ago seismic activity beneath the surface caused a large portion of central Kansas to sink slightly, producing the basin that was destined to become Cheyenne Bottoms. But the cycle of events most pertinent to its condition today began less than 100 thousand years ago, when relatively dry terrestrial habitats were periodically invaded by cool, moist forests from the north. The pollen content in local core samples indicates that these cycles have continued up to the present, which is one of the drier of these epochs.

The marsh in the bottom of the Cheyenne Bottoms basin is affected by virtually everything that goes on uphill from it. Gravity drags water downhill, along with anything it is carrying. At the bottom of the basin it drops its load, producing the thick sediments so characteristic of the marsh. Emergent vegetation and the water surface itself also snag

Marais des Cygnes Waterfowl Area along the eastern edge of Kansas. This fertile wetland area hosts thousands of migrating birds on their trips north in the spring and south in the fall. (Linn County)

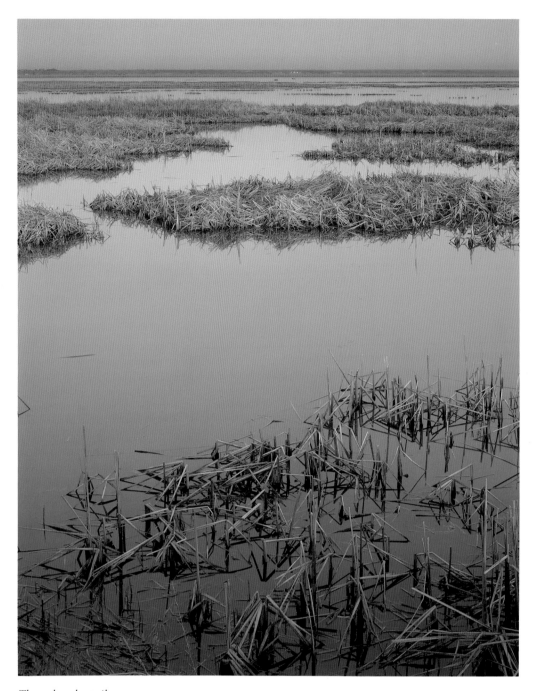

The reeds and cattails
of Cheyenne Bottoms
(Barton County)

dust particles from the air and add them to the deposits. Cheyenne Bottoms is shallow –
a deer can run across the marsh without getting its shoulders wet – so it will fill quickly,
transforming itself within hundreds or thousands of years from a bowl to a saucer to a dry
tableland. In the meantime, though, it is a dynamic and awe-inspiring habitat, with a bio-
logical diversity that is unusual anywhere on the continent.

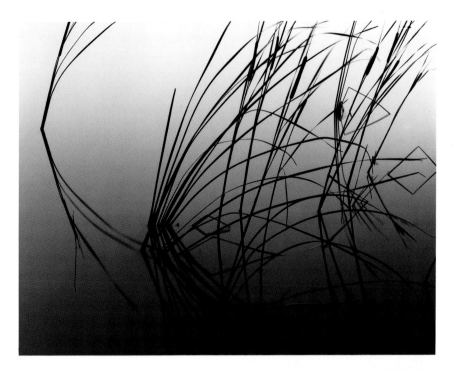

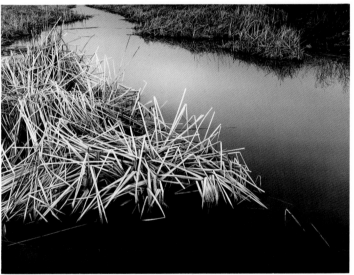

*Cattails in Cheney
Reservoir State Park
(Reno County)*

*Reeds at Cheyenne
Bottoms (Barton County)*

Cheyenne Bottoms is recharged not only by rainfall, but by surface flow. However, the two major creeks that replenish it, Deception and Blood, drain a watershed of less than 100 square miles, so their contribution is relatively insignificant. Thus, Cheyenne Bottoms must rely on rainfall for most of its water. In average years, more water evaporates from the surface and from the leaves of plants than falls in the region, so the marsh is always on the verge of a deficit. Within just a year or two of a season of above-average rainfall, the marsh can be dry if it is not recharged.

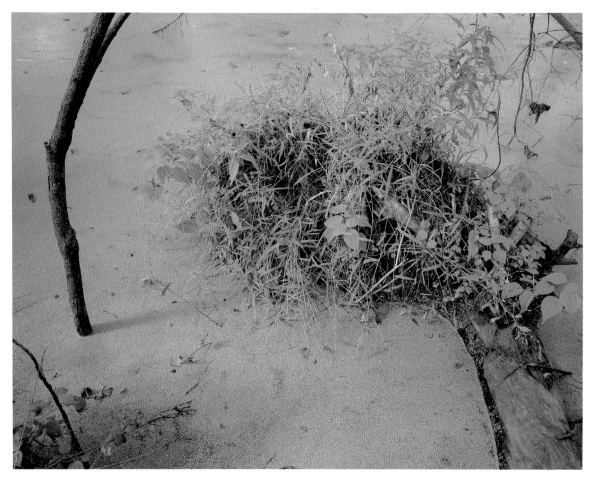

In the heavy heat of late summer, ponds become choked with algae, duck-weed, and emerging plants. (Clay County)

It is not simply the water that draws so many visitors, human and otherwise, to Cheyenne Bottoms; it is the life that the marsh supports. Microscopic algae capture sunlight and turn it into food for the next link in the food chain. The algae are eaten by tiny invertebrate organisms, which in turn are consumed by insects or their larvae, and perhaps by small fish. Larger fish, amphibians, and birds may feed on these, and at the top of the food pyramid, perhaps four or five steps removed from the first level, are predators such as snapping turtles, snakes, raptors, and mammalian carnivores.

This is a classic chain of resources, one that we assume typifies most natural communities – everyone either eats or is eaten. But in the marsh, the real action may be in decomposition, a process that is undramatic and perhaps unappealing, yet vital to the marsh's ecological health. The vast majority of organisms probably die from the nicks and cuts of life rather than the sudden pounce of a predator. Tiny aquatic organisms starve or suffocate in the muck of the marsh and unceremoniously fall to the bottom, accumulating in

layers to become the next epoch's sediments. Droughts kill and dessicate plants, or strong winds blow them over, snapping their internal lifelines. Larger animals may lose the battle against infection from a wound or be fatally hobbled by breaking a limb on an unseen snag.

Eventually, most of these dead plants and animals settle to the bottom of the marsh, where they are consumed by bacteria and fungi. Here the elaborate structures that individual organisms have developed through conception, birth, and growth are broken down once again to essential elements and are recycled through another generation. The entire cycle, the basic process of the natural world, is exposed at Cheyenne Bottoms for a visitor to perceive – to see, hear, touch, and smell.

If any place in Kansas can be said to have global significance, it is Cheyenne Bottoms, especially since so many other wetlands in North America have been destroyed. Each spring and fall it becomes the stage for one of the most spectacular events in the natural world, when up to 600 thousand migrating birds, particularly shorebirds, stop at Cheyenne Bottoms to refuel for their long flights. This immensely productive marsh sits in the middle of the Central Flyway, a migratory superhighway from the temperate and tropical regions of the south to the tundra and high Arctic in the north.

Many bird species migrate through Kansas, but it is the shorebirds that rely most heavily on Cheyenne Bottoms. The plovers, godwits, sandpipers, and dowitchers fly north in the spring to breed in the marshy circumpolar tundra. This habitat is extremely harsh and inhospitable for most of the year, but during a brief period in summer, perhaps only two months, the reproductive efforts of its residents and guests coincide. Just as the birds begin to require food to produce eggs, incubate them, and feed their offspring, the tundra begins a crescendo of food production.

Shortly after the chicks leave the nest, the entire population begins its expedition south, just ahead of the harsh winters. Flying 25 to 50 miles per hour, the birds set out while the days are still relatively long and they can cover great distances during daylight. Their destination is the productive lowlands and shores of Central and South America, where they will overwinter before returning north once more.

This vagabond lifestyle is very costly. It requires an enormous number of calories, which only places like Cheyenne Bottoms can provide. So huge flocks of migrating shorebirds cascade into the marsh for a day, or for a few days, each spring and fall to rest and build up their reserves for the next leg of their journey. There are two other continental flyways, along either coast, but approximately 45 percent of the shorebird migration visits Cheyenne Bottoms coming or going. A few species make a loop, incorporating Cheyenne

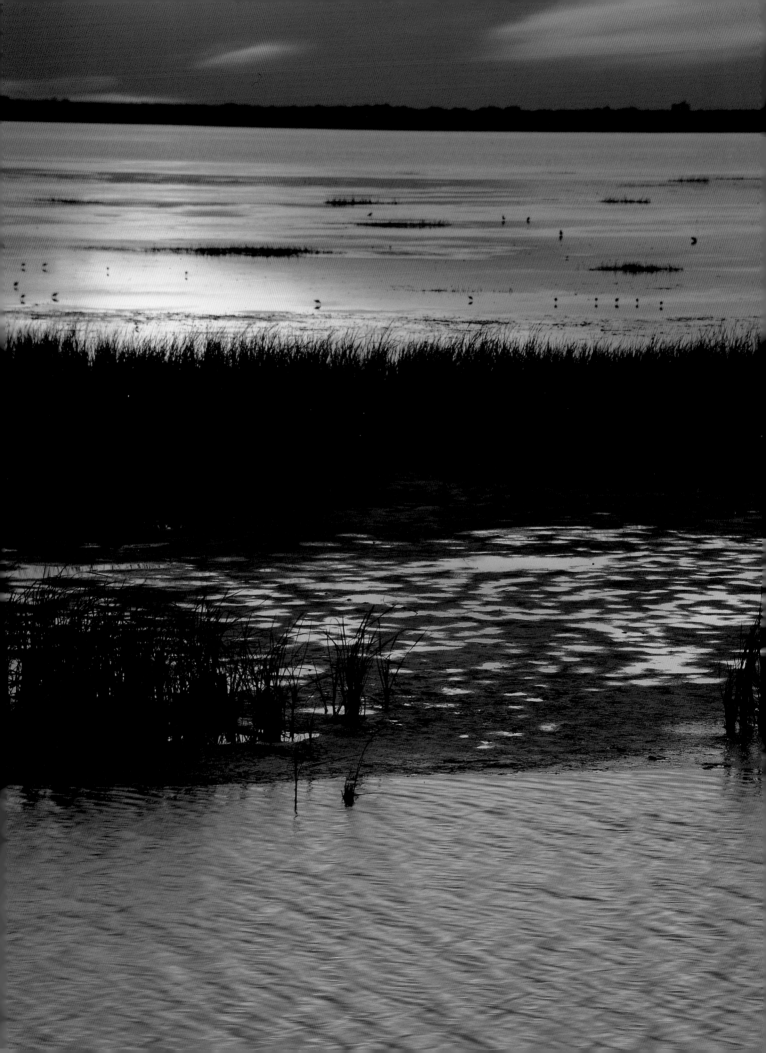

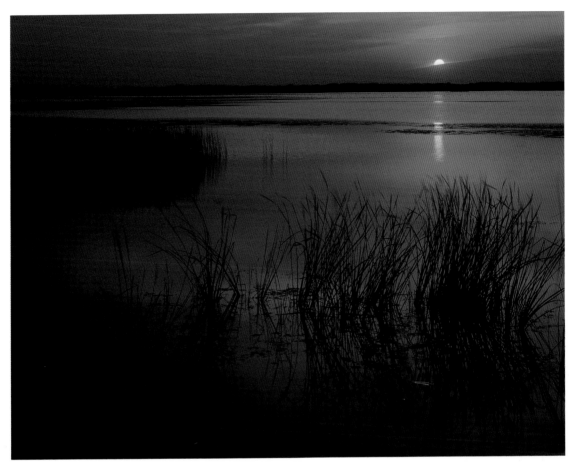

*Big Salt Marsh, Quivira
National Wildlife Refuge,
a wetland very similar to
Cheyenne Bottoms – except
for the fact that the waters
of Quivira are salty.
(Stafford County)*

*Facing page: Cheyenne
Bottoms, a wetland of
global significance, hosts
hundreds of thousands of
migrating waterfowl and
shorebirds. (Barton
County)*

Bottoms into their itinerary only in the northward leg before circling down along the Eastern Flyway on the way south, and consequently, the marsh hosts fewer birds in the fall than in the spring. Either way, Cheyenne Bottoms is an essential rest stop for avian visitors – it makes their extravagant lifestyle possible.

Thirty miles south of Cheyenne Bottoms is Quivira National Wildlife Refuge, a marsh that superficially resembles Cheyenne Bottoms but is different in one critical detail: Quivira is a salt marsh. The water in Cheyenne Bottoms is saltier than drinking water, but Quivira water is much more so. It lies in an area where various salts, including gypsum and sodium chloride, are abundant, and its initial saltiness is created by dissolved salt from this parent material. Evaporation further concentrates the salts as the water in the marsh vaporizes and leaves behind the residue of salts. Like Cheyenne Bottoms, Quivira is host to hundreds of thousands of migrating birds (270 species have been identified at the site).

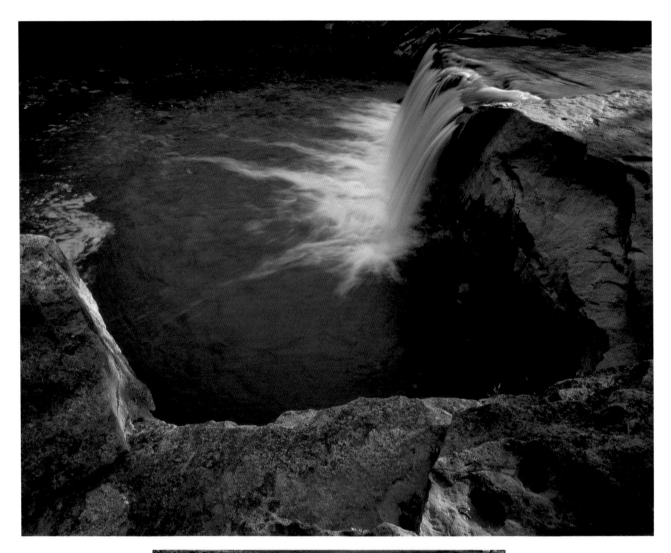

Even the slightest drop in the surface allows gravity to pull water downhill, eventually wearing down the landscape. (Elk and Wabaunsee Counties)

Seeps, swamps, and marshes are fittingly labeled wetlands because they are terrestrial habitats that are periodically inundated with water. Rivers and streams, however, are all water – 20,600 miles of them in Kansas. These moving bodies of water gouge and erode the landscape, incessantly altering everything they touch. What is not scoured away is dissolved and eventually washed into the sea.

Plants and animals living in water face conditions that are almost the opposite for their terrestrial counterparts. On land, organisms must be concerned about losing water – drying out to the point that they cannot survive. In most rivers and streams, water constantly percolates by osmosis into the living tissue of organisms, diluting their vital juices to the point of ineffectiveness. Imagine, then, the physiological changes that must occur when a dragonfly larva emerges from several years in the water to become a completely terrestrial adult, or when salamanders first take up the terrestrial habit after several years as freshwater creatures.

Another important difference between these two habitats is that rivers and streams are always moving, however listlessly. Unless their inhabitants are willing to be washed into the sea, they must hold onto something – with suckers, claws, or threads – or equip themselves somehow to resist the current. A moving habitat also means that conditions can change rapidly. Runoff from upstream eventually passes by every location downstream, so if the discharge from the land surrounding the waterway contains harmful pesticides or other chemicals, a disaster may result. For obligate water dwellers, though, the ultimate disaster occurs when the stream dries up.

The big rivers of Kansas have had a tremendous impact on the landscape and its inhabitants, including humans. The Missouri has etched out the northeast corner of Kansas, and its banks offer some of the most distinctive forest habitat in the state. The Arkansas has meandered back and forth across the southern third of the state, carving a variety of landscape features, creating unique habitats, and hauling material from the west into the High Plains of Kansas. Indigenous drainages, such as the Solomon, Saline, and most of the Smoky Hill and Republican, pour into the Kansas River; the Neosho, Walnut, Chikaskia, Ninnescah, and Verdigris run south and leave the state.

These drainages – indeed, all drainages no matter how small, have incised the surface. Most of the major rivers and streams in Kansas flow west to east, though they tend southeasterly in that corner of the state. These east-west flows have left behind long fingers of land between their modest canyons, and it is on this high ground that the major highways have been built, giving vacationers the false impression that Kansas is flat.

Geologists can describe the conditions of presettlement rivers, but only a few places

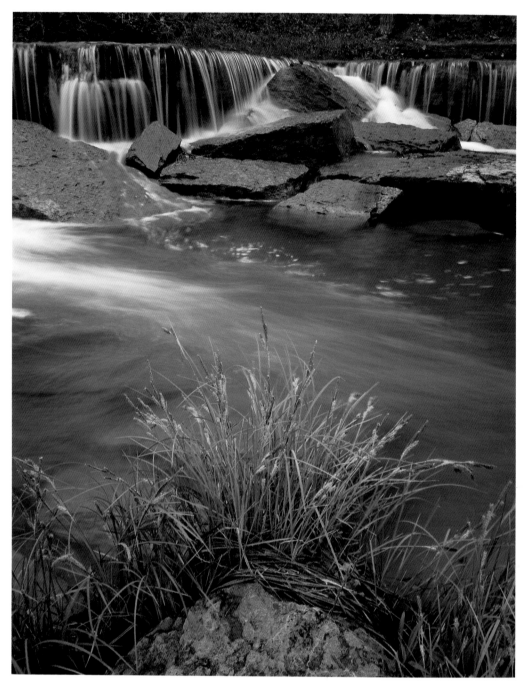

Pillsbury Crossing,
Deep Creek (Wabaunsee
County)

still provide a glimpse of what our watersheds were like 200 years ago. Kansas waters almost surely ran clear for most of the year over sandy bottoms, and broad meanders supported distinctive floodplain communities of grasses, forbs, and trees.

The rivers and streams of contemporary Kansas are different. Plowed land extends right to the edge of drainages, often without even a fringe of trees along the waterway.

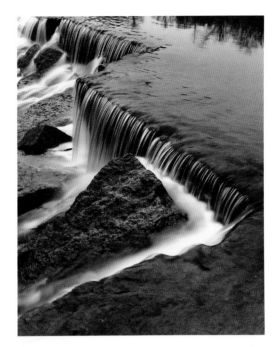

Sharp edges and smooth water at Pillsbury Crossing (Wabaunsee County)

The broad Missouri River, where it takes a bite out of the northeast corner of Kansas (Doniphan County)

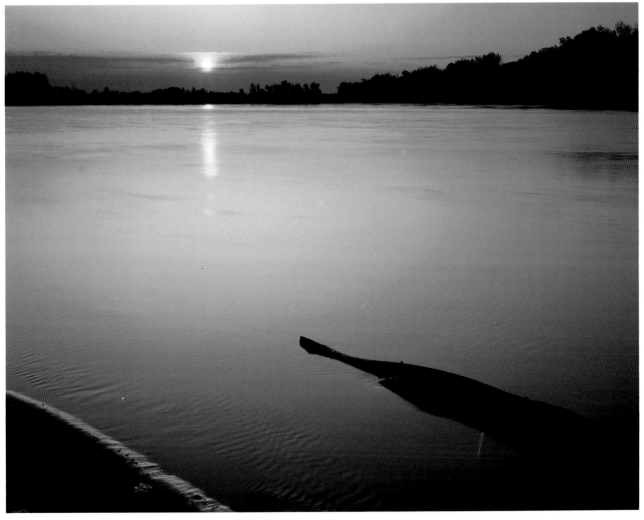

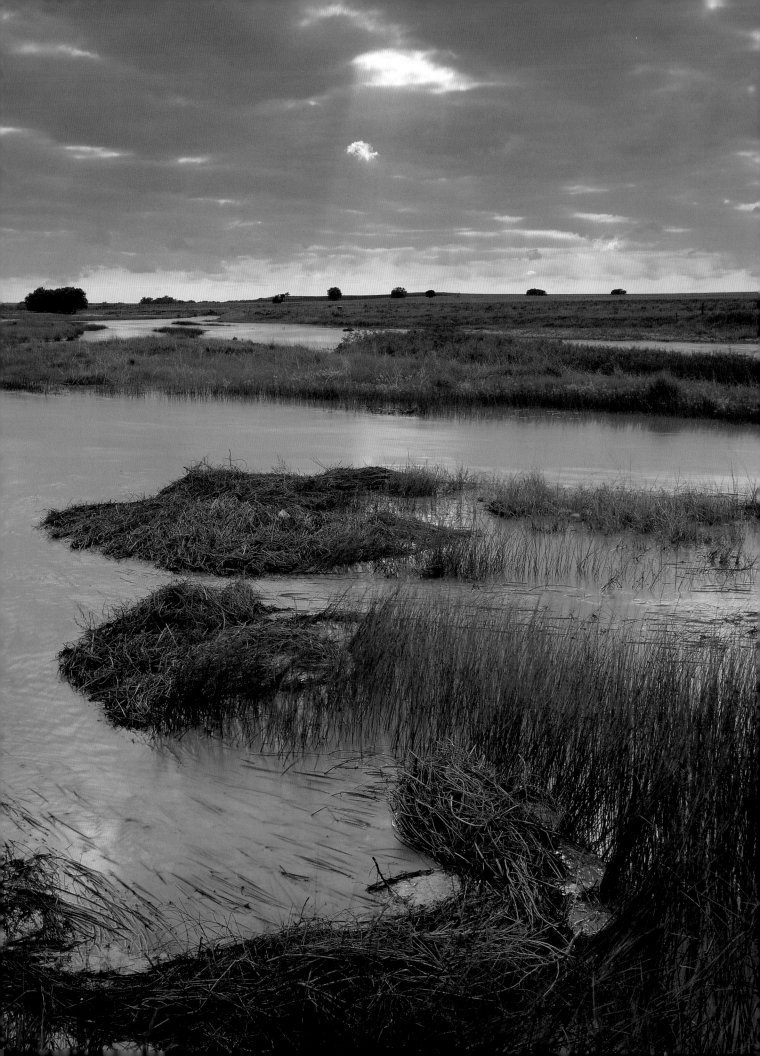

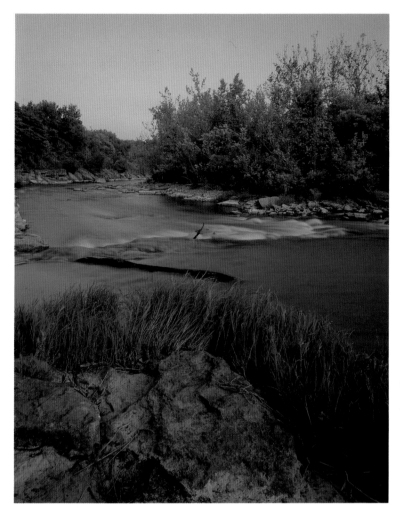

Left: Sedges along Mill Creek (Wabaunsee County)

Above: Sandbars in the Kansas River (Pawnee County)

Facing page: Floods periodically sweep the river banks clean and pile debris downstream. (Smoky Hill River, Gove County)

Topsoil, and all of its high-tech additives, drains off the surface and into the water, turning it to liquid dirt. Livestock and their effluents foul the water further, and the effects of these "additives" compound downstream, turning Kansas streams into some of the most turbid soups in the Great Plains. Extensive agricultural and domestic use of both surface water and groundwater has compounded the problem by reducing flows and concentrating pollutants. So what were once appealing, perennial streams are now without charm – piddling dribbles between channelized banks lined with skeletons of cottonwoods. The decline of surface flows has slowed a bit in the last 10 years, but it will take decades more to replenish these precious resources.

One of the few creeks still in near pristine condition is Kings Creek on Konza Prairie. The two forks of the creek begin on the protected research site and coalesce near its northwest boundary. Because it begins in a relatively unsullied tallgrass prairie, it does

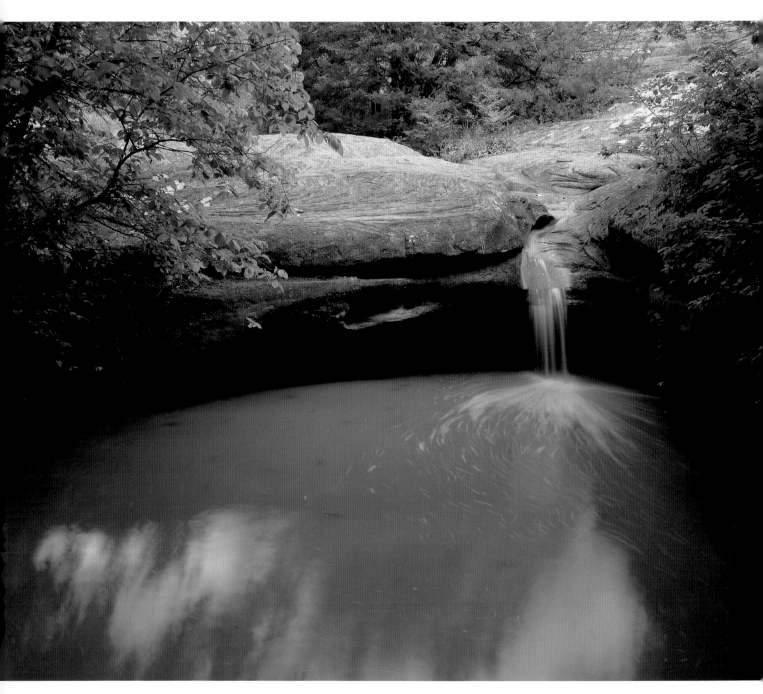

Waterfall over
Ireland Sandstone
along Tauy Creek
(Douglas County)

not receive the typical inputs from adjacent agricultural land (although some minor in-
vasions occur through the air). Hence, it serves as a benchmark creek for the U.S. Geo-
logical Survey and an ideal research site for characterizing Kansas creeks. The creek flows
through an oak gallery forest and over layers of ancient limestone, producing knee-high
waterfalls. It contains stretches of perennial flow and hosts 19 species of fish, dozens of

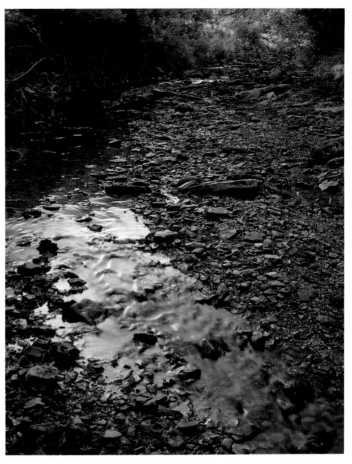

Kings Creek originates on Konza Prairie and flows for several miles through the research reserve. Its waters are among the clearest in Kansas. (Riley County)

kinds of insects (especially their larvae), and scores of algae. The Flint Hills is also criss-crossed by other attractive creeks, such as Mill and Deep Creeks. The Red Hills host Barber Creek, and in far western Kansas, Ladder, Driftwood, and Beaver Creeks add to the quality of the landscape.

The need for flood control and a reliable water source has led to the construction of dams and their attendant reservoirs. Though we might imagine that the dam-building efforts of the European settlers were the first attempts at water management in Kansas, evidence suggests that Native Americans used irrigation along Beaver Creek in the mid-seventeenth century. Modern dam building began in the 1920s but was accelerated after the droughts of the 1930s. Since then, flood control became a driving force behind the construction of dams, especially after devastating floods along the Kansas River drainage in 1951. Now, a quick glance at a map of Kansas reveals at least two dozen large reservoirs, and the state now claims 168,000 acres of water spread over thousands of "lakes" and ponds.

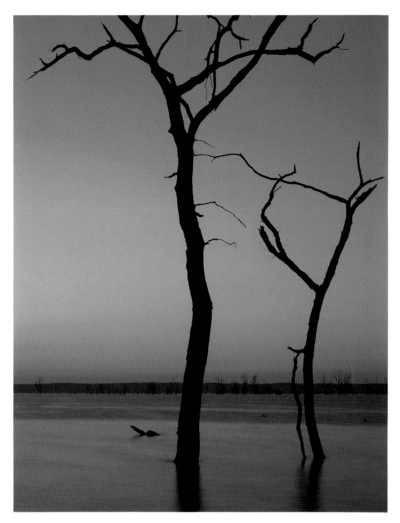

A snag in Clinton Lake stands as a reminder of the land that was inundated when this reservoir was built. (Douglas County)

At first glance, many of the reservoirs seem to belong in the landscape; large bodies of water fit so naturally in canyons. The frogs chirping along the shore and the trees lining the coves add to a sense of the native. At the downstream edge, though, is the dam – the inevitable scar. The dam may be disguised with vegetation, but its geometry gives it away, too precise to be an accident of nature. Reservoirs may be valuable to humans, but they should not be considered part of the natural landscape of Kansas.

Not only does water, the essential liquid, sustain life, but life also issues from it. Many plants and animals spawn their offspring in the seeps, marshes, lakes, streams, and rivers of Kansas. Here, they take advantage of seasonal riches to mature and take up their role in the cycle of life. Kansas waters can be unbelievably productive. For example, it has been estimated that a single square yard of Cheyenne Bottoms may produce over 55 thousand midges, small flies whose larvae proliferate in the muddy flats of the marsh. The larvae are

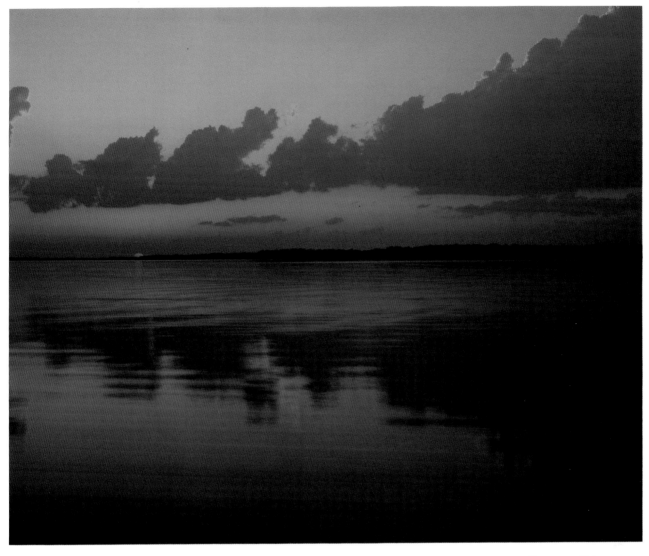

Sunset over Pomona Lake, a reservoir that looks almost natural (Osage County)

eaten by probing shorebirds, and when the adult midges emerge in swarming clouds, they provide another feast, this time for frogs and lizards as well as birds.

As it flows downhill, water gathers information about its watershed, and even a small water sample can reveal surprising events upstream. The analysis may be informal – a salty taste on the lips or a certain color sediment – but more technical analysis can disclose as much information as a blood sample. Water moving under and across the landscape soaks up evidence of activity along its path that, when deciphered, divulges the history, health, and prospects of the landscape it drains.

Native Americans were spiritually attached to water, in some cases revering amphibians for their association with this life-giving aspect of the environment. The esteem we hold

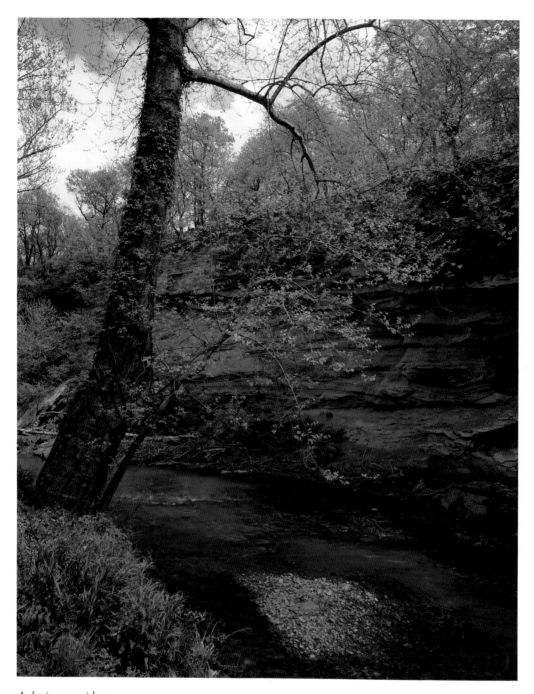

A classic streamside scene:
sycamore and long-leaved
phlox along Mission Creek.
(Wabaunsee County)

for water may also be tied to our evolutionary origins in the primeval seas and to the comfort of the womb. Hard-wired in the genes of every organism is the recognition that water is a critical ingredient for the continuation of life.

In Kansas, the agricultural center of the United States, we are particularly aware of the need to preserve water and wetlands, since water is essential for the survival of our crops

and livestock. We cannot afford to squander this environmental capital by frivolously wasting water, and we must support attempts to return some of our domesticated waterways to their original pristine condition.

Concentrating, as we naturally do, on visible bodies of water, we forget that water also flows underground, eroding and dissolving rock to create caverns. Occasionally these caverns erupt onto the surface to reveal an opening to a cave. In human terms, caves are defined as underground spaces large enough for a person to enter and deep enough to be dark. But Kansas is riddled with natural holes and cracks that might be defined as caves on other creatures' smaller scales.

A huge proportion of the information we gather about the environment comes to us via what we can see. Hearing is also important to us, especially the ability to detect loud noises or distinct changes in sounds, and smell can trigger specific images. But in caves, where light and odors are all but absent, where the only sound is the drip of water, our senses seem dulled. This sensory deprivation puts us on the alert, sharpening our attention to what few stimuli exist. Artificial light gives some comfort, but we still know, in the back of our minds, that we are foreigners in these places.

Most caves in Kansas occur in the limestone (southern Flint Hills, Osage Cuestas, and Ozarks) and gypsum (Red Hills) areas of the state, and hundreds have been documented. Several types of caves occur in the state. Perhaps the most familiar type is the wet limestone cave formed when slightly acidic water begins to dribble through tiny cracks in limestone. As the watercourse becomes entrenched, it dissolves and carries away the most susceptible stone, eventually hollowing out a cavern. If the cave was formed by water flowing through a horizontal crack in the parent material, it will tend to be a horizontal ellipsoid, like a hollow egg on its side. Upright caves are generally created by water flowing vertically.

Often water flows constantly through these wet limestone caves, usually in a small stream that trickles along the bottom of the cave, and where particularly aggressive erosion took place, pools may develop. Limestone caves tend to form in a single stratum. In the relatively thin layers of Kansas limestone, then, caves are usually no more than 20 or 30 feet high, but they can be thousands of feet long. Openings to underground caverns are often quite small and difficult to locate, and by the time they have enlarged enough to form an entrance, the cave may be on the verge of collapse. Schermerhorn City Park, in the very southeast corner of the state, contains a lovely wet limestone cave that those curious about these haunting structures in the landscape can explore.

The most common kind of cave in Kansas forms in the gypsum beds of the Red Hills. Gypsum dissolves much more quickly than limestone, so these caves come and go rapidly,

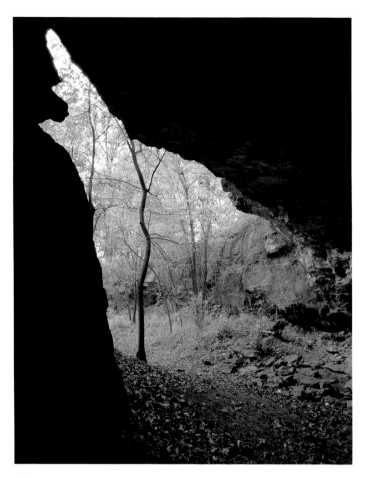

The entrance to Schermerhorn Cave, Schermerhorn City Park (Cherokee County)

even when compared (in geologic time scales) to the limestone caves. Hundreds of gypsum caves are known in Kansas, most between 100 and 300 feet long. Unlike limestone caves, gypsum caves are usually dry until flooding rains strike the region, and then they may become completely filled with water and large debris. As a result, gypsum caves develop episodically rather than gradually, as limestone caves do.

When either of these types of caves emerge above the water table – because of either upward movement of the earth's crust or a lowering of the water table – they become dry caves. Without the driving force of water, which is responsible for both the birth and the death of caves, these black holes in the landscape can persist for centuries. Many animals use them for shelter, and anthropological evidence (including pictographs, petroglyphs, and pottery shards) suggests that Native Americans used them as well.

One of the defining features of caves is their darkness. Sunlight drives the biological world through the photosynthetic process practiced by most plants. Without light, photosynthesis cannot take place and cave ecosystems must import energy from the outside

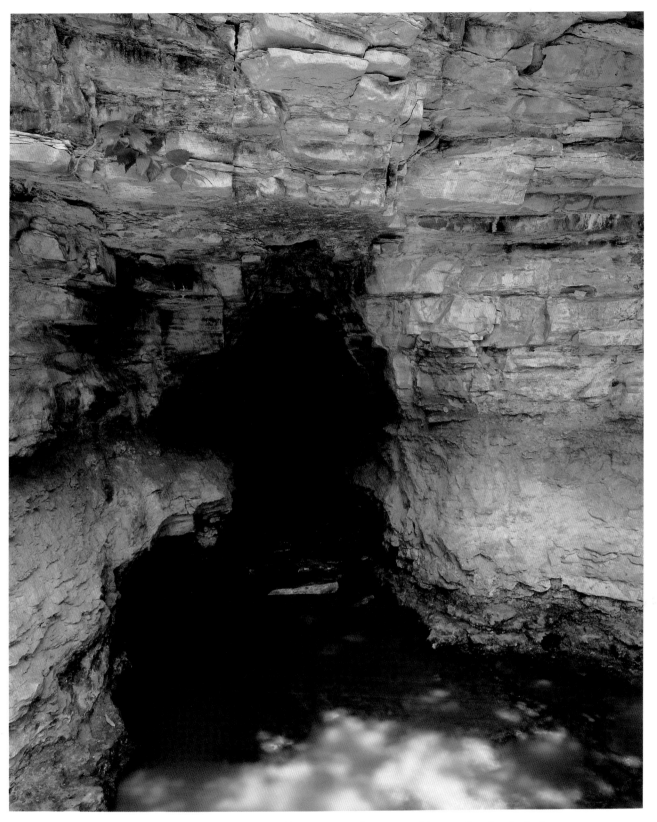

*The mouth of a limestone cave with its characteristic wet floor, a trace of the water flow that dissolved
the rock and hollowed out this hole in the earth (Spring Cave, Butler County)*

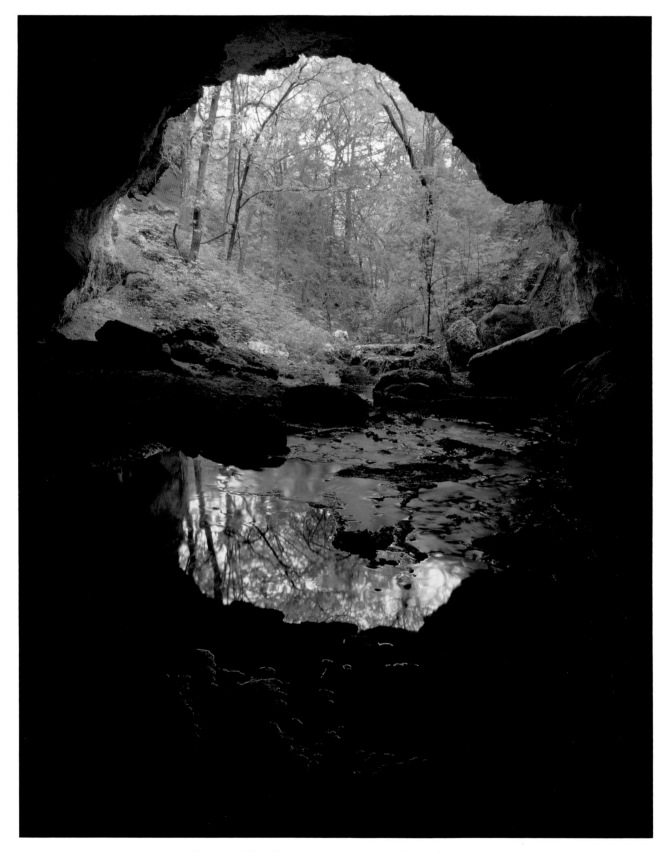

The mouth of Pope Cave in south-central Kansas (Comanche County)

world. Carbon and other essential elements may be blown in or carried in by water or animals. But this is an unreliable life support system, so cave communities tend to be low in both population and species diversity.

What they lack in quantity they make up for in uniqueness. Most of the animals found in caves are simply opportunistic. Raccoons, coyotes, foxes, woodrats, and skunks may come and go through a cave entrance, using it as shelter or a hunting locale. Salamanders often take advantage of the soggy conditions in caves (almost exclusively in the Ozark Plateau caves), and one species, the grotto salamander, is essentially restricted to this habitat. Bats are the animals most often associated with caves, even though relatively few are found in Kansas. A few species, such as Townsend's Big-eared Bat and the Cave Myotis, use caves as roosts between foraging bouts. The shelter that caves provide to inhabitants and casual visitors alike is safe, moist, and cool, relieving them of some of the stresses of the above-ground world.

Some of the most bizarre creatures on earth are obligate cave dwellers, or troglodytes, adapted to life in the dark, sterile depths of caves. These creatures are often blind, colorless, and have slower metabolisms than their surface-dwelling counterparts. But because Kansas caves are relatively young and often short-lived, they have not developed a full set of troglodytes. Only a few specialized invertebrates (such as worms and insects) can be found in Kansas caves and in the surrounding groundwater.

Caves, like canyons, lure visitors onward with the promise of what might be around the next bend. But they are also mysterious, enigmatic, and eerie. Even though we are curious about what we might be able to discover in them, their dark, confining realms seem to issue a warning: return to your sunlit homes above ground and leave the depths to those with keener senses of touch, smell, and taste.

PROCESSES

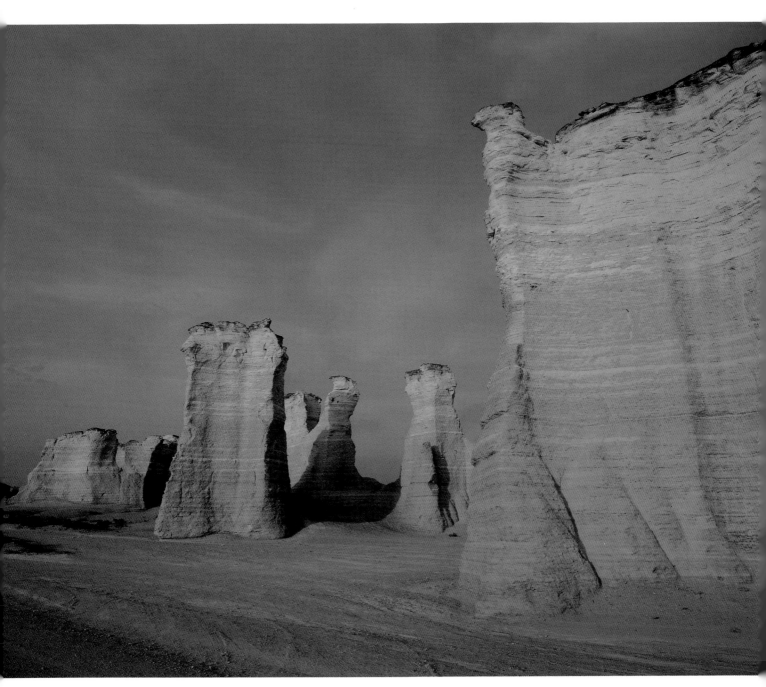

These chalk formations of the Monument Rocks reveal the processes that produced the layers
by deposition and sculpted them by erosion. (Gove County)

t is impossible to describe the landscape of Kansas without hinting at the processes responsible for its form. Clearly, water has been a major player, from the scores of marine invasions that laid down the foundation strata to the incising rivers, streams, and creeks that whittled these layers into fanciful forms. Again and again over the past several million years shallow seas have intruded from the southeast and northwest, then receded. In their processions and recessions these warm bodies of water laid down the limestone and shale strata that are so characteristic of the state. Then gravity, and its proxy, erosion, steadily and subtly sculpted the surface – until another marine invasion reset the surface to a flat, even veneer.

Sitting at the geographic center of a large continental mass has advantages: it means that Kansas was not a part of the dramatic episodes of mountain building that created the coastal ranges. So rather than the massive mounds of the 400-million-year-old Appalachians or the awesome pinnacles created by the events that built the Rockies 60 to 80 million years ago, the topography of Kansas resembles a blanket after the first attempt to spread it on a bed, mostly flat, but everywhere rumpled and uneven.

Its central location has also spared Kansas major volcanic and seismic events, at least over the last several million years, although volcanic ash has periodically blown in from California, New Mexico, and Wyoming. Perhaps the most dramatic surface event occurred about 750 thousand years ago, when the Nebraskan and Kansan glaciers – sheets of ice two miles thick – ground into the northeast corner of the state. The glaciers scraped south and west as far as Wamego in Pottawatomie County, depositing quartzite boulders from the north on the abraded surface.

Most of these geologic processes relied on small increments of change over extremely long periods of time. Such events could not be accounted for in a lifetime, or even in the entire period humans have existed in North America. When people first arrived 10 to 15 thousand years ago, the continent looked much like it does today. Because of the recent glaciation, the boundaries of plant communities were still a bit farther south, but the Flint Hills already showed their characteristic bench-and-slope configuration, and the Arkansas River was meandering within its floodplain along a path it had followed before and would follow again.

Many events perceptible within a lifetime, a day, or even a few minutes also have an irreversible influence on the landscape. The regional climate – and its daily perpetrator, weather, for example – can have serious consequences both seasonally and event by event. And in approximately the same time scale, but perhaps in a slightly smaller spatial scale,

the activities of animals greatly affect the land. Individually, an earthworm leaves a relatively insignificant mark, but taken as a whole, earthworm populations play a critical role in what happens to the Kansas landscape.

The climate of a region is the long-term average of all of the day-to-day weather patterns. So if the data were available, scientists could average the weather over the entire 4.6-billion-year history of the planet and characterize "the climate." But this information is not available, and even if it were, it would obscure the regional variations that have shaped unique landscapes and environments.

Because the distant past of Kansas – from about half a billion years ago until 50 or 60 million years ago – was characterized by scores of invasions of shallow seas, Kansas was alternately an ocean floor and a low, moist shoreline. During some of these periods Kansas was uplifted; during glacial periods the seas receded when much of the earth's moisture was captured by huge glaciers and the polar ice caps; but most of the time the maritime environment prevailed, whether the land was terrestrial or marine.

Once the center of the continent settled into its terrestrial habit, the climate of Kansas was most affected by the rise of the Rocky Mountains. The Rockies became a high barrier that interrupts and alters the flow of moist air from the northwest down across the continent. This air ramps up the western slope, cooling as it rises, which causes much of the captured moisture to condense and fall as precipitation west of the continental divide. As the air slides down the east side of the mountains, it warms, and like a dry sponge, absorbs moisture across eastern Colorado and western Kansas through evaporation. This wedge of drying air extends into the upper Midwest and defines the "prairie peninsula," an extension of prairie habitat that extends east across Illinois. This air flow pattern persists today, although the native prairie has been drastically reduced.

Overlain on this general pattern of weather-generating air flow are the most recent (within the past 150 thousand years) glacial epochs. As the ice sheets plowed south, they brought with them local climates ranging from today's northern Canadian climate to the dry prairie conditions that currently prevail (we are now at the height of an interglacial period). Some of the best evidence about Great Plains environments of the time comes from pollen samples taken from marsh deposits. The strata in core samples reveal not only that cool and warm environments alternated, but that the transition between them was strikingly rapid. These climatic reversals, on the order of decades, suggest that the transitions did not occur uniformly over centuries. Rather, temperature and precipitation patterns reached a threshold, perhaps engendered by the baseline air flows from the west, and

quickly switched. The vegetation seems to have followed suit, since the change from one community to another – from boreal forest, for example, to oak woodland – took only 60 to 125 years.

The features of the recent Kansas climate – entrenched air flow and roaming glaciers – have slowly altered the topography, both by influencing precipitation patterns and by scouring the surface. But the landscape we see today results mainly from the accumulated effects of daily weather and a spattering of catastrophic events, such as floods and tornados. In Kansas the weather changes every two or three days, and over this short period of time it's fairly predictable. Over longer periods, though, the weather at any one place is extremely difficult to predict, because temperature, moisture, and wind are all highly dependent on global patterns of air movement. These patterns are affected by the sun and, more directly, by the earth's warming in response to the sun, as well as to some extent by the rotation of the earth.

Meteorologists and atmospheric physicists have constructed elaborate computer models of global weather patterns, but even the most powerful computers have trouble applying these simulations on a level meaningful to a big bluestem or collared lizard. So the most predictable feature of Kansas weather is still its variability. We have been snookered by TV weather programs into thinking of averages, but averages are made up of deviations.

There are, however, general patterns to the weather in Kansas. The state is endowed with all four seasons which, while they blend almost imperceptibly, are distinct at their midpoints. Summer is warm, relatively still, and often humid. The landscape is intensely green and buzzing with cicadas. Autumn is long, with cold nights and cool days. The vegetation changes color and settles into bronze, yellow, and brown. Winter is dry – even the snow sounds like crunching popcorn underfoot – and also brown, although the shade is dusty, not the rich brown of fall. Spring in Kansas can be wet and dramatic. In gray-green skies, spectacular thunderheads generate immense power and sweep across the plains, dumping hail and rain.

There is also a general geographic pattern to the climate of Kansas. The east is cooler in summer and warmer in winter than the west. It is also wetter, averaging about 40 inches in the southeast compared to 15 inches in the far west. Not surprisingly, humidity follows similar patterns. The south is also warmer than the north and receives less snow in a typical year.

But these general patterns are so widely known, they fail to capture our attention. It is the extremes that set the standard by which we remember a particular season or a particu-

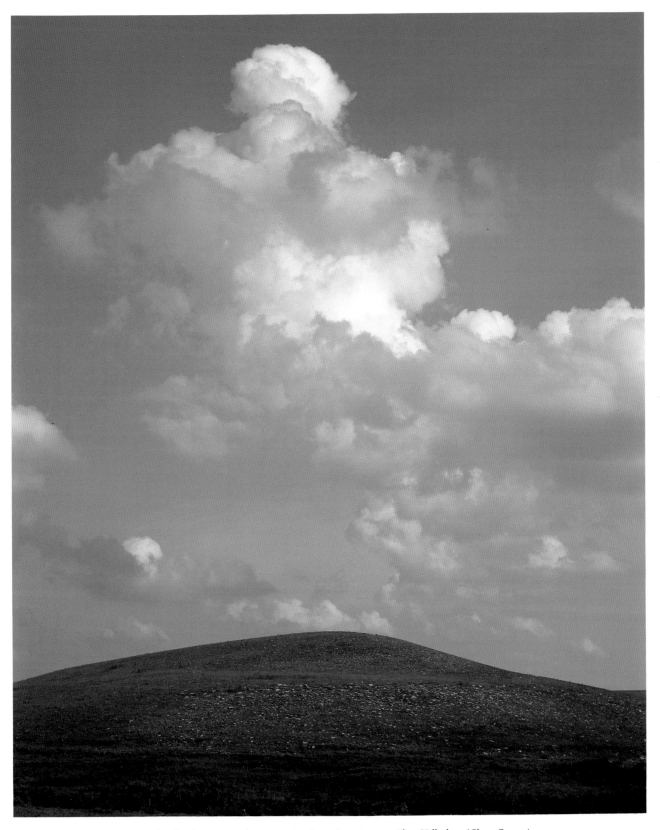

Cumulus clouds over grass shoots emerging in early spring on a Flint Hills slope (Chase County)

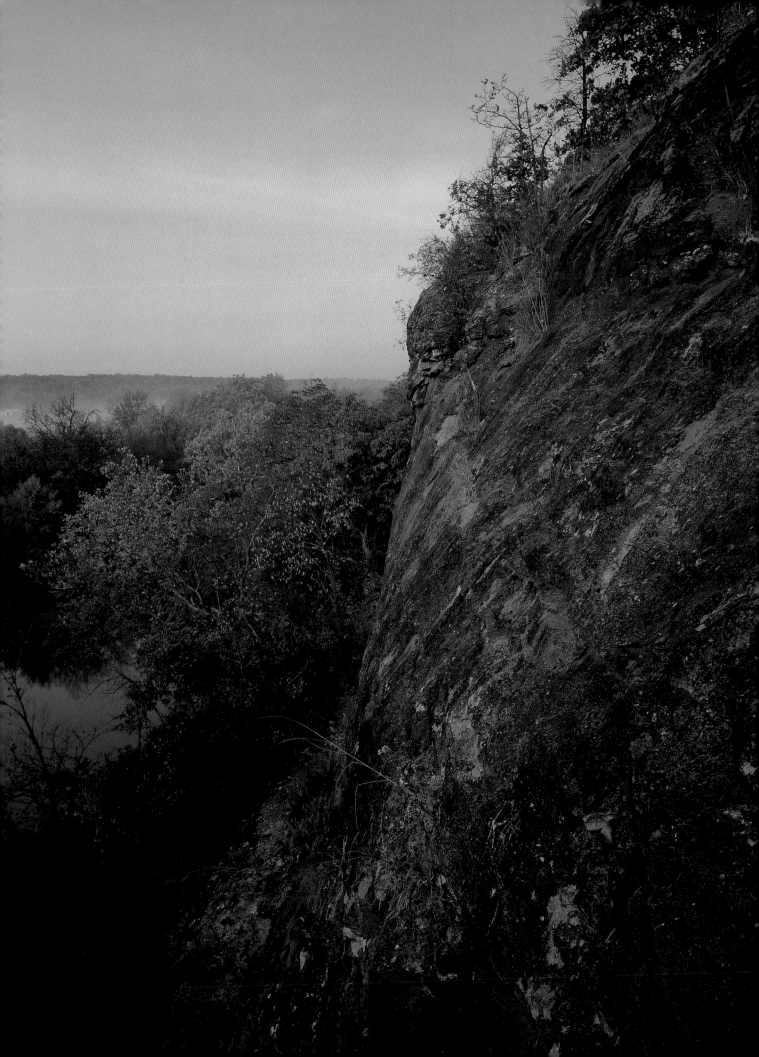

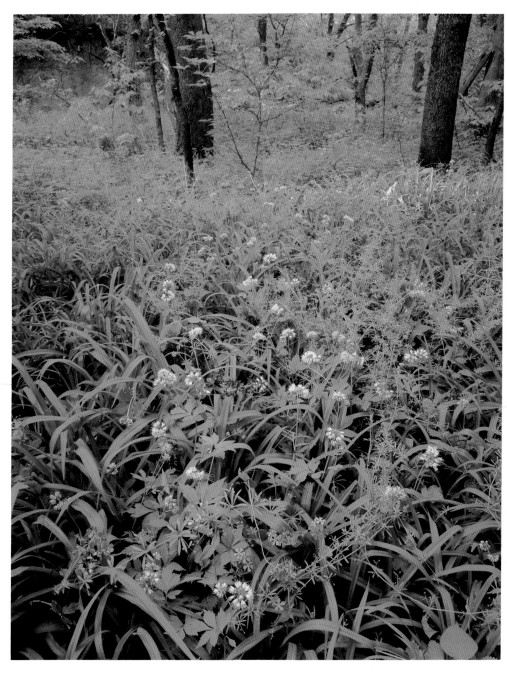

*Virginia waterleaf
and sweet William
in full flower during
summer in the forest
(Douglas County)*

*Facing page:
Summer turning to
fall in Schermerhorn
City Park (Cherokee
County)*

lar year, and by which the plants and animals of Kansas gauge their success. Temperatures over 120 degrees have been recorded, as well as temperatures as low as minus 40 degrees. Some cold snaps last days, inexorably drawing the life from organisms. An ultracold blast of air may doom many creatures at the margins of their northern range, especially if it's not accompanied by an insulating layer of snow.

Skeletons of sunflowers
resist the frigid winter.
(Logan County)

Droughts are just as dangerous as temperature extremes. Plants, especially, have come to rely on spring rains in Kansas. When the rains don't come, the hot, dry summer kills many of them. Those that do manage to survive and flower may find that their pollinators are not present to assist in their courtship, themselves victims of the drought. When dry years are strung together, the damage grows geometrically. The last year of the drought takes a much higher toll than the first, seizing even the hardiest of residents.

Floods last a much shorter time than droughts, but their impact is immediate and catastrophic. Monumental volumes of water can surge across the landscape and down drainages, rising scores of feet above the typical flow in a matter of minutes and burying some plants and animals. Large pieces of earth may be pried from the banks and disintegrate in the water, drowning its underground inhabitants. The physical damage caused by abrasion and collisions with flood debris can be even more devastating, however.

The selection of survivors of these events is a natural process with no particular goal, a simple arithmetic phenomenon that weeds out those that cannot endure. This process of

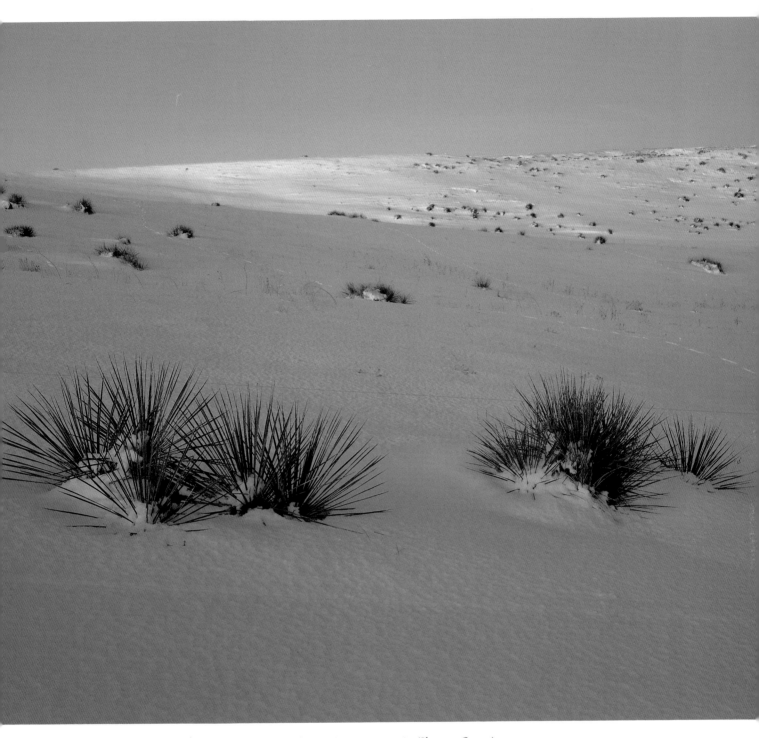

Sharp-edged yuccas at a winter sunrise (Sherman County)

As high waters from a flood recede, the residue of debris remains. (Mill Creek, Wabaunsee County)

selection may mean that mammals clever enough to find warm shelter will outlive those less clever, halting the spread of their genes and the inadequate behavior they engender. Selection of drought-tolerant plants, particularly reflected in the structure of grasses, has clearly promoted the development of prairies in Kansas. Weather extremes that persist over seasonal cycles will sort out the quick from the dead and ultimately leave behind suitably robust offspring.

Because temperature has so much to do with our comfort, it is perhaps the first component of weather we evaluate when contemplating the day's activities. For better or worse, our technology has rescued us from the rigors of thermal extremes. Now we live mostly indoors where we can make winter warm (often too warm) and summer cool (of-

ten too cool). But long before we thought of electricity and refrigeration, Native Americans had imagined environmentally sound methods for keeping their homes at livable temperatures. Often they lived in caves that faced south – cooler in the summer and warmed by the low light of winter. Early settlers, too, situated their houses to catch summer breezes but avoid winter blasts, and planted trees for shade and windbreaks.

Living organisms operate by the complex interaction of proteins, primarily enzymes that mediate all biochemical processes. These reactions are temperature-sensitive to a point – in general, every 10-degree increase in temperature yields a twofold increase in the rate of the process. The physical structure of proteins is especially sensitive to high temperatures and can be fatally disrupted by modest increases (for example, consider what happens to the white of an egg when it encounters a hot skillet). All plants and most animals tend to take on the surrounding ambient temperature (that is, they are "cold-blooded"). To survive and prosper, they must locate where conditions are at least minimally tolerable. Plants, which generally cannot move once they germinate, will scatter seeds over the landscape in a lottery to increase the odds that some offspring may survive. Animals have more flexibility, since they can often move to a more benign habitat, or construct one.

Unlike cold-blooded animals, birds and mammals physiologically control body temperatures to keep them within a narrow range. When they find themselves outside this range, they must spend energy to cool or warm themselves. Even with remarkable adaptations for coping with extreme temperatures, it is often the thermal environment that limits the distribution of many organisms.

This principle is evident in broad geographic patterns. Hundreds of plant species adapted to southern climates are limited in their northern range by the cold of winter. Southern trees such as magnolias might do well in the Kansas summers but falter farther north, where frosts come earlier and stay later. Cold-weather species such as northern birch and spruce, on the other hand, find Kansas too hot and dry for their taste. Only highly mobile animals, such as migrating birds, can pick and choose when to visit Kansas. Almost all others must be able to tolerate, or hide from, temperature extremes.

Plants and animals are also affected by temperatures on the microhabitat level. Species that survive on relatively cool north-facing slopes may get roasted by the direct sunlight of a south-facing slope only a few yards away. To extend their tolerances a bit, the creatures that persist in Kansas have taken extraordinary measures to cope with temperature extremes. Plants that could easily overheat if left to boil in the sun use their top leaves to shade and protect the delicate leaves below. Cacti and yuccas take the opposite approach, using their thin needle-like leaves to radiate heat into the wind. Most animals spend at

least some time each day underground, where they are buffered from the extremes of the surface world. Some simply burrow into the soil while others, such as woodrats and beavers, construct cleverly engineered dens of sticks.

Temperature and moisture are linked: warm air is able to hold substantially more water than cold air. The moisture content of air is therefore reported as "relative humidity." This measurement describes the amount of moisture contained in the air at a particular temperature, relative to the maximum amount of moisture that it is possible for the air to hold at that temperature. When a weather forecaster on the morning news tells us that today's high will be 90°F at 60 percent relative humidity, we can expect a much more humid day than if the forecaster's reading was 60°F at 60 percent relative humidity. In other words, air saturated with moisture in the dead of winter is drier than even the driest air of summer. This principle also explains why water evaporates more quickly in warm air.

These physical relationships are reflected in the landscape. Somewhere near the eastern edge of the Flint Hills, evaporation and precipitation are nearly equal. In Douglas County, for example, 35 inches of precipitation falls annually, and about that much evaporates from the surface of Lake Perry. Farther east, where precipitation slightly exceeds evaporation, the excess is used by plants and animals or flows into streams or groundwater. The relative abundance of water speeds the geological processes of erosion and dissolution in these areas and generates lush vegetation.

West of the region where precipitation and evaporation balance, a water deficit develops. During most rainstorms, water falls faster than it can evaporate. But in the long intervals between showers, the hot, dry air sucks moisture from the surface, drying the habitat and slowing both the geological and biological processes.

Clearly, soils in western Kansas are not completely dry all the time. Tiny amounts of water cling to the surfaces of soil particles, held by a magnet of powerful molecular bonds. Plants, with yards of roots and perhaps miles of fine root hairs, constantly seek this veneer of water and pry it loose from the particle surfaces. This ability, coupled with numerous adaptations to prevent water loss, allows western plants to survive in soil that seems completely dry.

When we think of moisture, we think of rain, but water takes on several guises. On cool mornings after warm nights, water may condense in the air as fog. Or it may condense on the surface of the landscape as dew, a thin blanket of water that sustains life for many creatures. Snow makes up one-quarter to one-third of the precipitation in Kansas, coating the ground and insulating the dwellings of those living in the soil underneath. The effects of ice can be more insidious. Occasionally ice storms do major damage – for

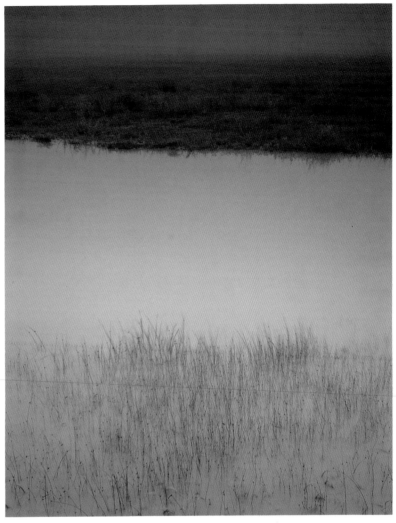

Fog is a common result of cool mornings, when water evaporates from the warm earth and quickly condenses in the cool air. (Smoky Hill River, Gove County)

example, the ice may accumulate on plants and become an unbearable burden. Paradoxically, it is the warmest spring and summer afternoons that produce hail, water in its most destructive permutation, which bombards the landscape, dents the earth, and thrashes standing vegetation.

Water has several qualities that make it especially important in the process of shaping landscapes. It is sometimes termed the "universal solvent" because its molecular structure promotes the dissolution of many chemicals, including soil minerals. This process eventually dissolves away the soil and transports it downhill and downstream.

Chemicals are usually at their most dense as solids, but water, oddly enough, is densest while still a liquid – at 39°F (4°C). This fact has two critically important consequences. For

The tips of a yucca plant, insulated from severe cold by a blanket of snow, at sunrise (Rawlins County)

one, it means ice floats. If water were densest at 0°F, ice would sink to the bottom of a body of water. Lakes and streams would then freeze from the bottom up, resulting in huge blocks of ice that would probably never melt, even in summer. Second, water expands with tremendous force when it cools from 39°F to 0°F (as it becomes less dense), prying rocks apart. We are familiar with the power of this phenomenon, exhibited when an aluminum can (or any container) bursts after being left in the freezer too long, or in frost heaving – when soil is pushed up as a result of water freezing and expanding below the surface.

When the earth heats up, air near the earth's surface also warms and expands, so that the air floats higher into the atmosphere. At higher altitudes it then begins to cool, and the moisture it holds may condense into clouds. Clouds have many effects on weather, one of which is to shade the earth beneath them and complicate the temperature pattern. In the spring, when warm, moist air from the Gulf of Mexico surges north and collides with cool air from the northwest, huge anvils of cumulus clouds form over Kansas. At their most powerful, they spawn deadly thunderstorms, lightning, and tornados. In a way, these ominous clouds are our mountains – the awesome, magnificent scenery on our western horizon. They build, explode, and recede before our eyes.

One of the products of thunderstorms, indeed the cause of thunder, is lightning. These intense flashes of light, so bright that they register through closed eyelids, can be deadly in their own right. Lightning often strikes trees and even animals, but its greatest impact comes from fire. Conditions must be just right for lightning to start a fire (dry vegetation and not enough rainfall to put the fire out), but with millions of strikes a year, there is ample opportunity for pyrotechnics.

The general flow of air across North America brings weather fronts from northwest to southeast. Depending on the air flow within the front (clockwise or counterclockwise) and its exact trajectory, the wind in Kansas may blow from any direction. However, the prevailing winds are from the north in winter and from the south in spring. March through May is the windiest time in Kansas, but strong winds can occur at any time.

In addition to these predictable patterns of wind, there are swift and unpredictable winds associated with thunderstorms. These weather rogues cause their own local movements of air as the atmosphere tries new physics experiments. During a thunderstorm, straightline winds can approach 100 miles per hour and then switch direction abruptly. Thunderstorms are also the breeding grounds for tornados. Winds in these spinning air masses reach speeds over 200 miles per hour, powerful enough to destroy everything in their paths. About fifty tornados hit Kansas each year, and each of them can leave a scar across the landscape that lasts for many seasons afterward.

Most of the components of weather are driven by the sun – a fact that may seem obvious with regard to temperature but farfetched when it comes to wind and moisture. However, differential warming of the globe's surface creates low and high pressure areas, which produce the general circulation of air around the world. Localized warming, particularly of the oceans, steers the rivers of air, nudging them north or south and causing ripples that directly affect our day-to-day weather. Kansas, at the crossroads of the continent, is touched by virtually every weather pattern in North America, and its landscapes are all the more interesting for it.

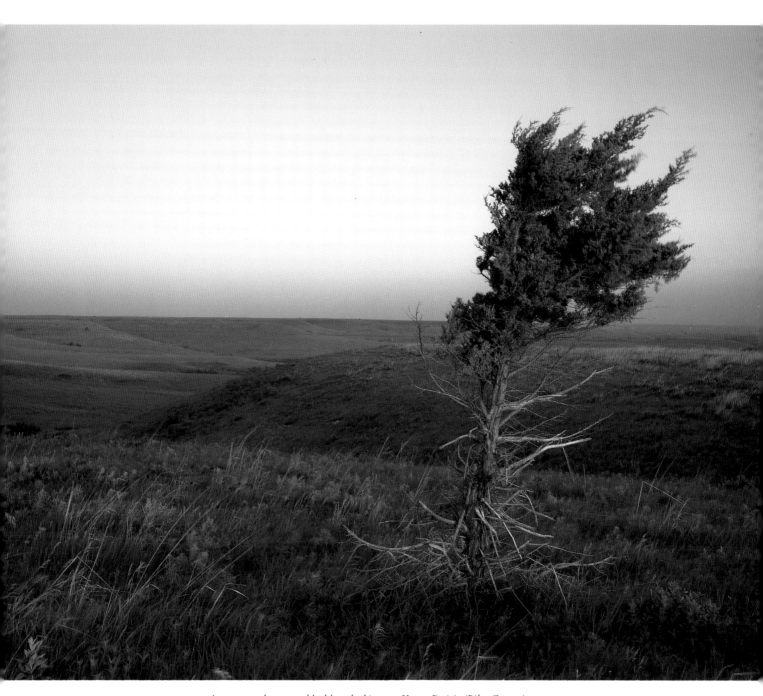

A mature cedar tree rubbed bare by bison on Konza Prairie (Riley County)

Plants and animals not only live in the landscape, they interact with it in ways that are infinitely more complex than the physical laws that govern our universe. Imagine a plot of tallgrass prairie one yard square. At first glance, and even after some scrutiny, it appears to be made up of some large grasses, perhaps a couple species of shorter grasses, and a few green plants. The only activity in the plot is the jostling of leaves in the breeze, or perhaps a lethargic grasshopper gnawing on a blade of grass. The drama of the hunt – predator on prey – is almost never seen.

This benign scene is misleading. To begin, almost two-thirds of the living matter in this habitat is underground. Just below the surface, thousands of animals, from nematodes and earthworms to moles and pocket gophers, move extraordinary amounts of soil each day. Insect larvae, on the verge of pupation, inch toward the surface to launch themselves on their above-ground search for a mate. Even on the surface, activity can escalate suddenly, when a regiment of bagworms emerges from its bivouac, devouring everything in its path. Over the course of weeks a little romance and a lot of death will take place on this plot, all governed by an unfathomable synergy of earth, weather, and species' behavior patterns.

Because of their sedentary ways, plants may appear to have little purpose beyond providing the vegetative backdrop for some lovely Kansas scenery. Nevertheless, plants directly influence the patterns of the landscape and the processes that form it. In their gentlest role, plants shade the soil's surface, easing the impact of the sun and generating pockets of quiet and solitude. The presence of vegetative cover greatly affects the local environment, aiding in soil formation by promoting the recycling of nutrients and providing for animals. Plants also moderate the exchanges between land and atmosphere – large, rough-surfaced habitats like forests may even influence the air flow and humidity patterns of their regional climates.

The roots of plants penetrate the ground, in some cases down dozens of feet into the earth. They are essentially hydraulic levers that force their way through the tiniest cracks in the soil, prying it apart and loosening the particles. Their pressure is relentless and eventually overcomes the hardest and most immovable objects. In the microscopic zone surrounding each root and every root hair, a distinctive chemical environment is produced that actually dissolves the earth and extracts its nutrients. Usually this process is imperceptible to us, since it occurs in that complex world below the surface; but we can see the same effects where years of ivy growing on the wall of a building has left acid-induced etchings. Millions, perhaps billions, of miles of roots snake their way into the rind

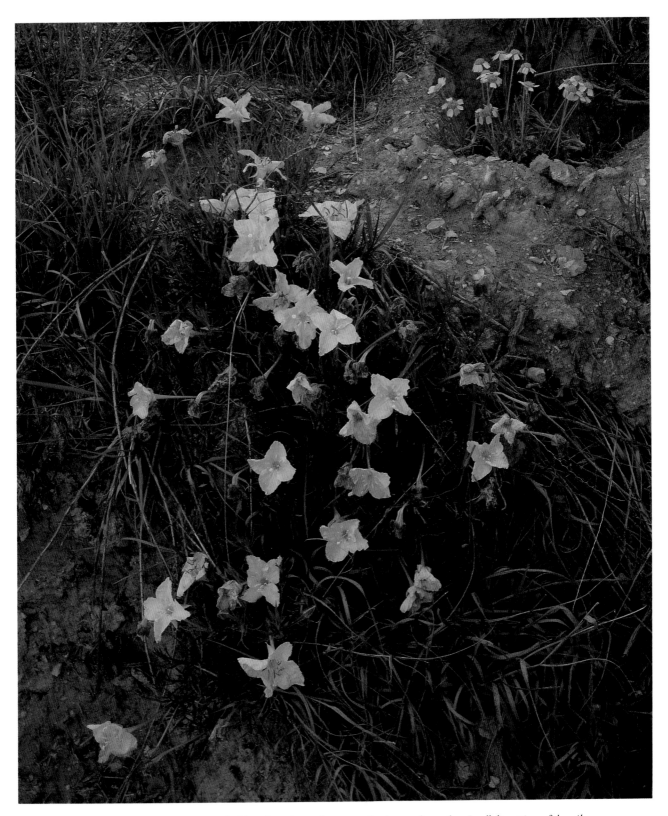

Evening primrose near a mound of dirt, the tailings of an excavation by a pocket gopher. Small disruptions of the soil surface such as this one provide shelter where specialized plants can flourish. (Gove County)

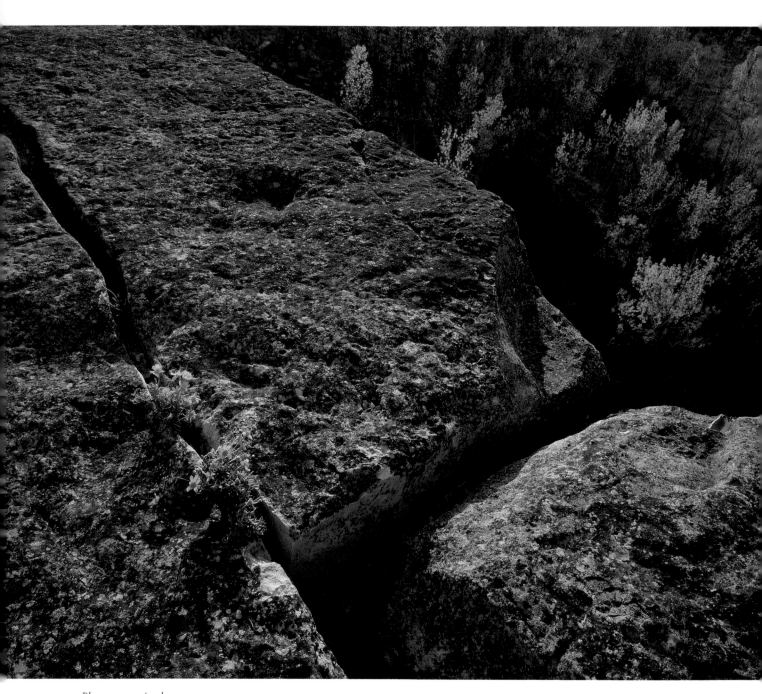

Plant roots patiently penetrate the smallest cracks, seeking nutrients and moisture, and in the process wedging rocks apart. (Trego County)

of Kansas, sustaining plant lives, mixing the soil, and counteracting the erosional forces of gravity and water.

Roots may crack rocks and break up large chunks of earth, but they also hold the soil together. Powerful streams and rivers can eventually loosen the grip of roots on the soil, but in the interim, roots strongly affect the path and extent of the scouring process. The

fine web of grass roots also forms the sod, a plant-earth symbiosis that is the organic pad beneath the prairie shag carpet. Sod is both the end result of decades of soil formation in the prairie and the glue that preserves the prairie once it is established.

Another role of plants is to serve as fuel for the fires that have nurtured many of the natural habitats of Kansas. The quantity of fuel available (i.e., pounds of plants) clearly affects both a fire's propensity to burn and its quality once it does ignite. Researchers have suggested an intriguing explanation of plants' role as fuel: grasses may have evolved to ignite easily in order to destroy competitors, those herbaceous and woody plants that make up the vast majority of species in Kansas.

One important effect of life on the landscape is engineered by the lichen, a fungus-alga team that works together symbiotically. Algal cells intermix in the fine hair-like strands of the fungus and contribute energy to the symbiosis. The fungus, in return, stores nutrients and shares them with the alga. Lichens occur on some of the most barren surfaces in the environment, even on bare rock, where they look like pastel splotches. These tough beauties digest the seemingly sterile rocks, or whatever they happen to be growing on, and make their minerals available to leafier plants. Lichens conduct their business at an imperceptible pace, but their contribution is critical: they set in motion the process of creating soil.

It might be easy to imagine that animals have a greater impact on the landscape than plants. Most animals move around, so they seem to have more opportunities to influence the landscape, and the results of their actions are immediately observable. We can watch a woodpecker drill a hole in a tree, or see the results of a badger's effort to excavate a ground squirrel from its subterranean den. Conversely, the activities of plants are much harder to see. A tree may take several years to grow a dozen feet, or an orchid may disperse its tiny seeds over great distances. The point, however, is not whether the flora or the fauna have a greater impact on Kansas – rather, it is their combined influence over time that has provided one of the fundamental forces shaping the landscape.

The large majority of animals directly influence the landscape by eating plants. Many have adapted special structures and processes to digest what the plant world has to offer, but even so, they are choosy eaters. Even grasshoppers – and there are scores of grasshopper species in Kansas – are particular about the menu. Some dine on grass, while others prefer herbaceous plants; some can handle the tannins in oak leaves, while others avoid them altogether. At the other end of the spectrum of size, animals as large as bison are selective feeders, brushing aside lush plants to get at the more appealing grasses.

When animals eat plants, they recycle the nutrients used to build the plants in the first

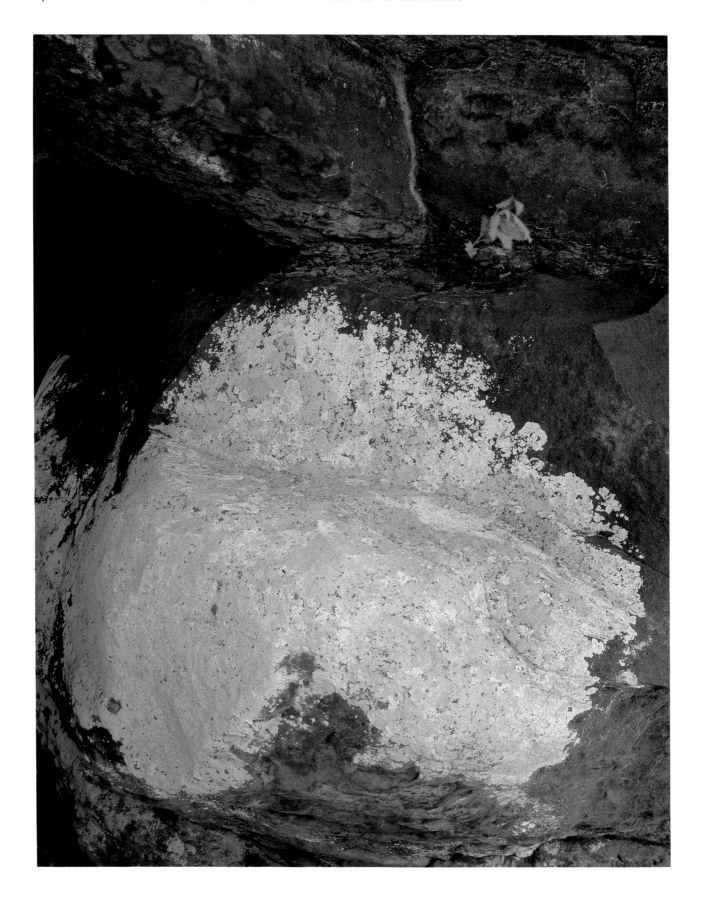

Lichens, made up of a fungus and an alga growing in a symbiotic relationship, stand out like splotches of paint on barren rock. (Ellsworth, Douglas, and Wabaunsee Counties)

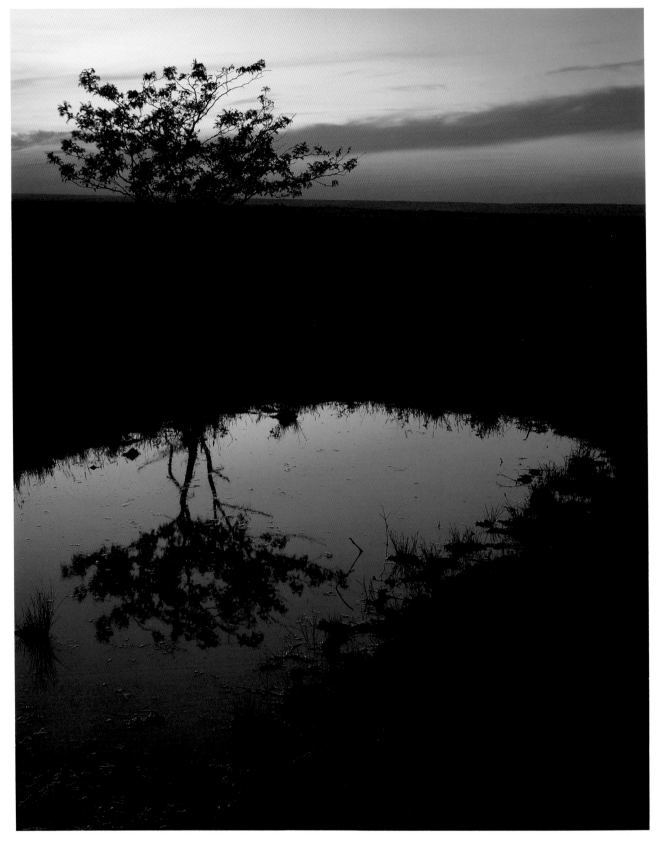

Animals affect the landscape in a variety of ways. This bison wallow has persisted for over a century in the tallgrass prairie. (Riley County)

In addition to consuming plants, animals affect vegetation in other ways, such as this bison trail through the oak woodland on Konza Prairie. (Riley County)

place. This is a rather inelegant process – the plant material is chewed, swallowed, digested, and excreted in a refined condition that is more easily decomposed by insects and microbes. Without herbivores, a habitat may become choked on its own resources, lose its dynamism, and grind to a halt.

Animals also influence the landscape in subtler ways. Some grazing animals actually eat the soil in an attempt to secure rare minerals, particularly salt. Since plants are extremely poor sources for salt (specifically, the sodium component of sodium chloride),

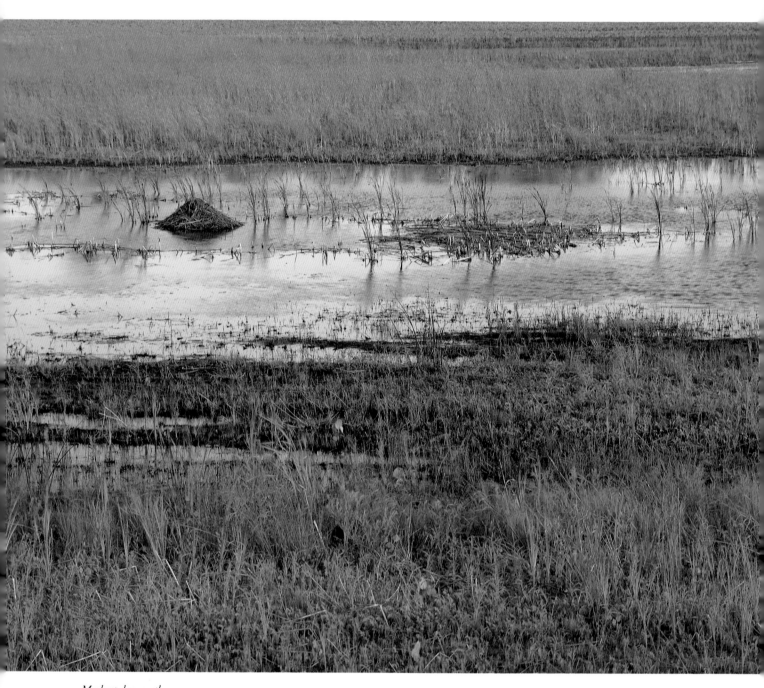

Muskrat dens on the Delaware River. Animals have a significant impact on their environment, in this case by cutting vegetation and altering the configuration of standing water. (Atchison County)

animals must take advantage of even the most diluted sources. Also, the footprint of a deer might become a microsite that ensnares a windblown seed. Soil may cover the seed just enough to protect it, and water may accumulate in the depression, providing the seed with moisture to germinate. This combination of conditions, multiplied by the billions of footprints animals leave on the soil, provides an incredible array of opportunities for plants.

Sometimes the effects of animals are severe – vegetation is trampled down or absent, and the soil is compressed. Throughout the prairie, buffalo wallows are still obvious. Prairie dog towns, riddled with hundreds or thousands of burrows, mounds, and openings, persist for decades after the towns have been exterminated or abandoned.

In some cases, because the soil is opaque, it is difficult the detect the impact of animals on vegetation and the landscape. For example, pocket gophers dig hundreds of feet of burrows and leave only the tailings on the surface to indicate their below-ground activity. While the smothering effect of the burrows is obvious, the unseen burrows themselves significantly reduce the amount of overlying vegetation and produce a ripple effect that influences plants several feet from each burrow.

These small disruptions influence the course of geological processes such as erosion. Water accumulates in a bison wallow, dissolving the chemicals and redepositing them in another condition or location. Rain washes down an animal trail, beginning an erosional path that could, over hundreds of years, lead to a new rift in the earth's surface. Even the engineering activities of beavers and muskrats significantly alter the course of geologic processes, producing new patterns.

Such alterations used to be considered "disturbances" by ecologists, but we now understand that plant and animal activities, as well as fire, are essential in maintaining the features of any natural landscape. Although the earth would continue to change in discernible ways without the influence of its plants and animals (as we see in the surface complexities of the Moon and Mars), their presence – particularly the "disturbances" they create – give the Kansas landscape its character and diversity.

The impact of our own species on the Kansas landscape is a different matter. We have participated in the vast ebb and flow of biological interactions that have occurred since the early ecosystems of the planet. With the development of technology, particularly the plow, the influence of our species has expanded exponentially. Now the naturalness of humans, once so much a part of nature, can actually be debated. Everywhere we look, we see the impact of our agriculture and our civilization on the Kansas landscape.

Regardless of whether we see ourselves as a natural species or as interlopers in the natural world, we have a capacity to appreciate the inherent beauty of the unmanipulated landscape, which coalesces in a way that is difficult to describe and impossible to duplicate. The silhouette of the Flint Hills could be reproduced with a bulldozer, but the real Flint Hills has edges without seams. Most of the trees that make up the eastern forests of Kansas can be grown in isolation or even in natural groupings, but neither the whisper of the forest nor its smell on a sultry summer day can be replicated in the lifetime of a human.

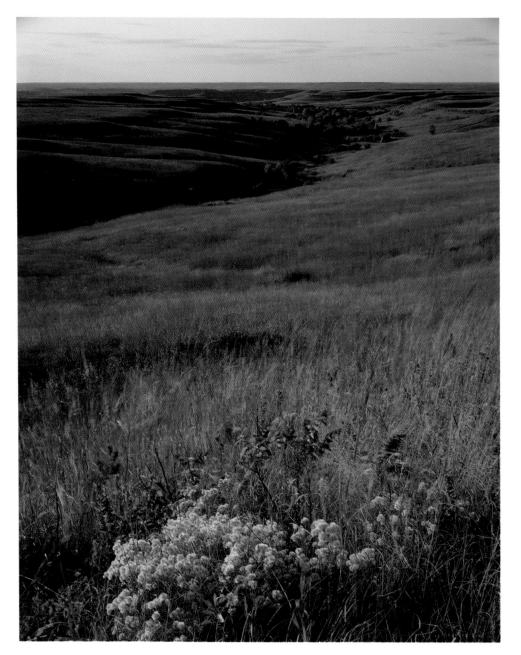

Autumn in the tall grasses of the Flint Hills (Riley County)

When we talk of "saving the planet" – including this region and this state – we must recognize that we are motivated by concern for our own survival as a species. Even if human culture were to end in the most cataclysmic way imaginable, the earth would still abide as a seedbed for new life. We have no need to invoke special justification for preserving the natural landscape of Kansas, because there are reasons enough to be careful with what we have – waking early to experience the freshness that follows dawn, peering through clear water at the creatures dwelling in a sandy creek bottom, standing on a rust-colored hilltop in prairie that stretches to the horizon.